T0383835

S U S P E N D E D MOMENT
The Architecture of FRIDA ESCOBEDO

SUSPENDED MOMENT
The Architecture of FRIDA ESCOBEDO

Edited by MAX HOLLEIN

THE MET The Metropolitan Museum of Art, New York

Distributed by Yale University Press, New Haven and London

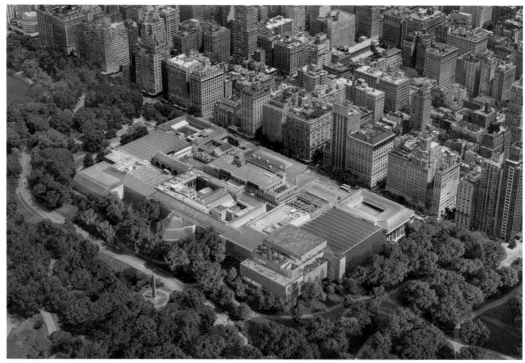

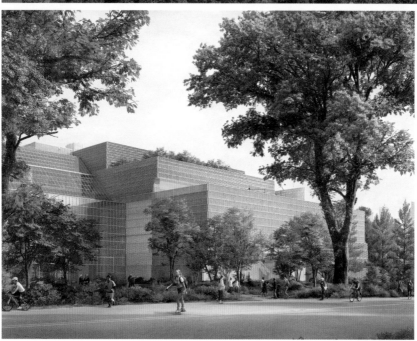

DIRECTOR'S FOREWORD Since its founding in 1870, The Metropolitan Museum of Art has grown to present the art of the past alongside that of the present. In 1967, when the curatorial department now known as the Department of Modern and Contemporary Art was established, the Museum stepped forward as a home for the art of today. The Met collection of twentieth- and twenty-first-century art has since achieved renown for its diversity of styles, geographic breadth, range of media, exceptional quality, and astonishing depth. Because the Museum collection reflects centuries of human artistic achievement from around the world, visitors can better appreciate its modern and contemporary artworks in their rich global and temporal contexts. This may be one reason that The Met is a favorite museum of living artists who, in their visits, find inspiration in our galleries. It is here that they enter into conversation with works that make manifest the vast sweep of human achievement.

As the Museum collection grew, so did its building. Since construction started on the Fifth Avenue location in 1874, it has expanded to represent a collage of architectural ambitions and styles. Frida Escobedo's contribution to this structure will be the design of the Oscar L. Tang and H.M. Agnes Hsu-Tang Wing. It will house the collection of the Department of Modern and Contemporary Art as well as works from the Department of Photographs and the Department of Drawings and Prints and related objects from the Museum's many collection areas, allowing The Met to more powerfully show the connections across times, places, and peoples that have been the driving force of the Museum's activity since its founding.

The Tang Wing will provide an expanded architectural framework for the display of The Met collection of twentieth- and twenty-first-century art, acting as a distinctive architectural achievement while also respecting and connecting with the Museum's existing mixture of architectural styles, spatial organization, and infrastructure. This new building will be a space for local and global communities to convene, further enhancing The Met's role as a center for shared experiences. The wing's surroundings, Fifth Avenue on one side and Central Park—itself a place for community, nature, and recreation—on the other, are the foundation for the building's artistic concept, which will be rooted in the soothing spirit of the park and infused by the energy of the city. The result will be a wing that prioritizes fluidity over classicism, engagement over prescription, surprise over expectation, and dynamism over uniformity. Frida Escobedo, an architect of extraordinary sensitivity and dexterity, is the ideal artist to bring this new vision into being.

On behalf of everyone at The Met, I wish to express our profound gratitude to Oscar L. Tang and H.M. Agnes Hsu-Tang, PhD. Their tremendous and catalytic generosity has played a critical role in activating this project. We are deeply appreciative of the unwavering dedication and tremendous support of our Board of Trustees, chaired by Candace K. Beinecke and Hamilton E. James, and John Pritzker, head of the Trustee Initiative for the new wing. It is their exemplary leadership in all aspects of this endeavor and the outstanding and most generous support of key Trustees of The Met that make this transformative project a reality. We thank each of the many donors who have supported this major initiative for twentieth- and twenty-first-century art at The Met—including, of course, Leonard A. Lauder, with the gift of his unparalleled collection of Cubist art. It is the dedicated philanthropy of our patrons that continues to make this undertaking—and all else at The Met—possible.

The Roswell L. Gilpatric Fund for Publications makes this volume possible, with additional support from the Director's Fund, and we are grateful that such resources can help us celebrate Frida Escobedo's vision in these pages.

Max Hollein
Marina Kellen French Director and CEO
The Metropolitan Museum of Art

Figs. 1, 2 Frida Escobedo Studio (Mexican, founded 2006), The Oscar L. Tang and H.M. Agnes Hsu-Tang Wing at The Metropolitan Museum of Art, New York (digital renderings)

6–7

A LATTICE
OF TIME:
FRIDA ESCOBEDO'S
WORK IN CONTEXT

Abraham Thomas

3

Frida Escobedo works at a variety of scales—from furniture and other functional design objects to intimate interior spaces to full-scale building projects. Working at a smaller scale has allowed Escobedo to explore approaches to materiality, craft, or texture, to work with new collaborators, or to prototype ideas that she might deploy later on a larger scale. These smaller projects provide opportunities for a laser-focused manifestation of ideas that have been continuous threads throughout her work. From the earliest stages of Escobedo's career, her broad research interests have provided the theoretical underpinning for her built projects; in much of Escobedo's furniture, design concepts, and research, it is possible to detect "a kind of proto-architecture," or a type of conceptual sketch that reveals an attitude that shapes many of her buildings and temporary installations.[1]

An early research project, *Split Subject*, was influential to many of Escobedo's principal strands of thought: the passing of time, memory and social history, texture and modularity, and public appropriation of space.[2] Originally developed as her thesis for her Master's in Art, Design, and the Public Domain at Harvard University's Graduate School of Design (GSD), *Split Subject* centered around a relatively anonymous modernist office building in the Colonia Juárez neighborhood of Mexico City, close to where Escobedo grew up, which she had observed closely since childhood (see pages 62–63). She was fascinated by the various material customizations that had taken place behind the building's glass facade, within each window compartment—for example, half-draped curtains, additions of drywall, or informal signs and advertisements taped to the insides of the windowpanes—resulting in an abstract visual language that she has likened to the rhythmic blacked-out bars of Marcel Broodthaers's *A Throw of the Dice Will Never Abolish Chance* (fig. 3).

Years after first observing this building closely, Escobedo staged several exhibitions and installations related to its anonymous facade—including at the Guggenheim Museum Bilbao in 2018—in which she utilized her own photographs of the building and even incorporated some of its actual windows, which she purchased herself as an act of preservation when the building was put up for sale. Escobedo was interested in how the facade's modernist grid allowed for "the life

inside the building to flourish and to be made more visible," within a rigid architectural structure that "was so neutral and so simple people appropriated it" to create "a collection of tiny interior moments that lived behind the glass facade and were able to grow like a coral reef while the people inside were still anonymous."[3] She posits that, through these half-hidden narratives, "Ornament becomes something that happens continuously . . . it is an expression of life."[4] Escobedo's project documents an unregulated development and accumulation that exists at odds with the facade's projected sense of vacancy and inscrutability, where "logic . . . has been populated with the disorder of reality [and] clarity is met with the scraps of necessity."[5]

According to Escobedo, this was a building that "evokes the same kind of excitement found in the contemplative nostalgia of ruins—however . . . as opposed to the process of erosion that a ruin may undergo, this building seems to slowly accumulate signs of time."[6] Expanding further in a lecture about *Split Subject*, Escobedo stated that "the architectural object develops via accretion and erosion; by inhabitation, appropriation, exchange, and agency."[7] This research project reveals Escobedo's long-held interest in how buildings shift over time, whether through changes in materiality or through their continual alteration by their users. *Split Subject* speaks to her openness in allowing her built spaces to be shaped by active participants, rather than passive users, in a collaborative process that explores the thresholds between design intentions, material reality, and the everyday use and function of these buildings.

This becomes apparent in her permanent buildings, but especially in temporary structures and participatory installations, such as her pavilions for the Victoria and Albert Museum, Serpentine galleries, and Museo Experimental el Eco. This kind of work has allowed Escobedo to engage with her fundamental areas of interest, whether that is by exploring the tension between opacity and porosity, testing the repeating textures of modular building units, opening up the potential for social interactions, or making a broader comment on the passage of architectural and material time.

OPACITY AND TRANSPARENCY

In the project that brought Escobedo broad international acclaim, her Serpentine Pavilion

Fig. 3 Marcel Broodthaers (Belgian, 1924–1976), *A Throw of the Dice Will Never Abolish Chance* (*Un coup de dés jamais n'abolira le hasard*), 1969. Printed by Vereman, Antwerp, published by Wide White Space Gallery, Antwerp, and Galerie Michael Werner, Cologne. Volume: 12^{13}⁄$_{16}$ x 9^{13}⁄$_{16}$ in. (32.5 x 25 cm). The Metropolitan Museum of Art, New York, Purchase, Bertha and Isaac Liberman Foundation Gift, in memory of Jeffrey P. Klein, 2015 (2015.590)

4, 5

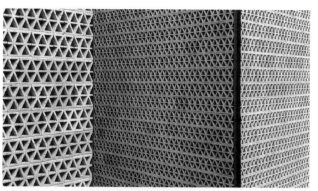

6

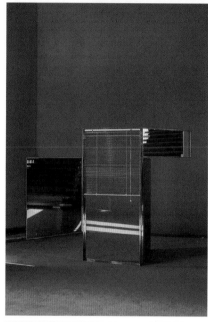

7, 8

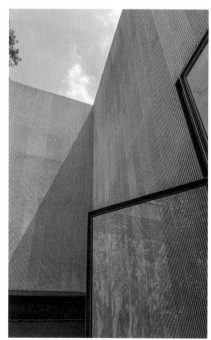

of 2018, open lattice walls constructed from local British roof tiles acted as a textured, permeable screen marking the perimeter of the pavilion (see pages 82–85). These tiles were stacked and offset to create a pattern suggestive of an open textile weave, but one with a geometric rigidity appropriate to the requirement for architectural screening and shading. This balance between opacity and transparency allowed visitors a view of the surrounding landscape of Kensington Gardens while also offering them a sense of protection and containment within a defined space. Inside the pavilion, a large mirrored ceiling hung over a reflective pool enclosed by the lattice screens. This caused the internal architectural volume to perceptibly shift and expand owing to the reflective surfaces, while the meshlike quality of the walls created a permeability that balanced feelings of privacy with a potential for performativity (fig. 4).

Six years earlier, Escobedo's renovation and expansion of La Tallera—the historic workshop of the Mexican muralist David Alfaro Siqueiros, which she transformed into a new cultural center with exhibition spaces, a bookshop, a reading room, and a café—also recast everyday building materials to create a lattice wall (see pages 58–61). For this project, Escobedo created a *celosía*—a breeze-block screen commonly found in Mexican architecture—to act as an envelope around the building and give it more of an institutional presence (fig. 5). Offering a practical solution to the humid climate in this region, these concrete blocks allow air to circulate and the building to breathe while simultaneously allowing sunlight to filter into the interior spaces. The decision to leave these blocks "raw" and unpainted was not only for reasons of cost efficiency, but also to address the future life of the project, giving it a material texture and surface patina that would age well over time while avoiding the need for costly maintenance and repainting.

These themes of opacity and transparency, concealing and revealing, and the utilization of reflective surfaces to contain and shelter all come to the fore with one of Escobedo's design objects, *Screen 01* (fig. 6). This object is simultaneously an example of small-scale architecture, a piece of functional furniture, and a sculptural proposition, while also presenting itself as an immersive, yet intimate, stage set of sorts. Its carefully choreographed assemblage resembles a traditional folding screen or room divider. Integrating moments of visibility and concealment, *Screen 01* suggests broader themes of privacy, daily personal rituals, performativity, and even voyeurism.

POROSITY AND EXCHANGE

With many of Escobedo's projects, the considerations of materiality can go beyond the technical balance of opacity with transparency, and instead encourage a different way of moving through and experiencing architectural space—often by merging the perceptions of interior and exterior. At La Tallera, there are moments when elements from the exterior, such as trees and rough stone gravel, suddenly interrupt the interior spaces. The *celosía* screen seems to reach out and gather these elements from nature to bring them inside. In other areas, trees punch through geometric apertures in the ceiling, revealing glimpses of azure-blue sky and glaring sunshine. In describing the related strategy of using screen walls in the Serpentine Pavilion, Escobedo stated, "We were interested in filtering the landscape into the space."[8]

This exploration of the thresholds between outside and inside is also visible in the design for Galerie Nordenhake, a contemporary art gallery in Mexico City, completed in collaboration with Mauricio Mesta in 2023 (see pages 104–5). Here, external courtyards, lush with greenery and trees, nestle themselves snugly at the front and rear of the building. The contrast between dense plant life, rough ribbed-concrete walls, and reflective surfaces of large glass doors serves to exaggerate the sense of an architectural volume multiplying and replicating itself, leaving interior and exterior space entirely merged and interleaved (figs. 7, 8).

Escobedo considers such architectural porosity a function of "the possibility of exchange,"[9] stating in an interview about museum architecture that "transparency would be full access," while "porosity is a gradient" that "requires a double responsibility: for the museum to become more permeable, but also for the observer to become more fluid."[10] She describes it as critical for the expression of texture; porosity allows for "playing with light, filtering certain things, unveiling them as you move. It's about how space starts to shift as you move through it. You discover things."[11]

Fig. 4 Frida Escobedo Studio, Serpentine Pavilion lattice wall, London, 2018
Fig. 5 Frida Escobedo Studio, La Tallera *celosía*, Cuernavaca, Mexico, 2012
Fig. 6 Frida Escobedo Studio, *Screen 01*, 2019. Glass, steel, and aluminum shade, 96 x 70⅞ x ¾ in. (244 x 180 x 1.9 cm). Collection of the artist
Figs. 7, 8 Frida Escobedo Studio and Mauricio Mesta Arquitectos (Mexican, founded 2010), Galerie Nordenhake courtyard, Mexico City, 2023

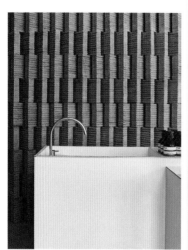
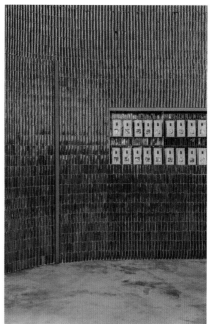

9, 10
11, 12

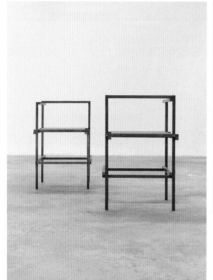
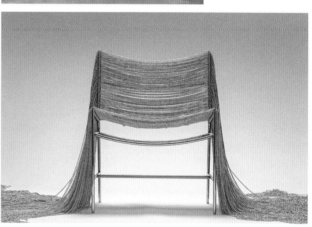

13, 14

MODULARITY AND TEXTURE

Many of the textures within Escobedo's projects are characterized by thoughtful choices of material that express an interleaved or woven quality through an application of modular, repeated construction elements. For example, her interiors for the skincare brand Aesop in Park Slope, Brooklyn, and for Niddo Café in Mexico City (also a collaboration with Mauricio Mesta) exemplify her use of modular building-block units to create intricate geometric patterns and surface textures like woven fabric—similar to her *celosía* screens for La Tallera and her stacked roof tiles in the Serpentine Pavilion walls. For the Aesop interior, Escobedo sourced rammed earth from Oaxaca to create handcrafted auburn bricks that were then tessellated into rhythmic formations that echoed the repeating, angled facades and intricate brickwork of the brownstone houses in the surrounding neighborhood (fig. 9). The Niddo Café interior is wrapped in a rich blanket of small green-glazed terracotta tiles, creating a delicate, temptingly tactile surface that glitters in the evening during low-light conditions (fig. 10; see pages 90–93).[12] Like the permeable interiors and exteriors at La Tallera and Galerie Nordenhake, at Niddo Café full-height folding glass doors allow the café to open entirely to the street, and for the streetscape to insert itself into the café's interior activities, with the vibrant green tiling acting as a vivid threshold that blurs the separation between these zones.[13]

Two of Escobedo's furniture projects offer interesting elaborations of this strategy of using modular elements to create a sense of texture and transformed space. In *Chair 01* (fig. 11), copper rods that seem almost like rudimentary engineering components are stacked into a subtly offset composition, creating a series of geometric forms that resemble the floating planes of Gerrit Rietveld's De Stijl furniture from the 1920s. In contrast, for her *Creek* series, conceived in response to Ana Mendieta's 1974 experimental film by the same name, Escobedo draped lengths of nickel-ball chains (reminiscent of the pulls used for blinds like those appearing in *Screen 01*) over minimalist supporting structures to create furniture that explores the idea of a surface's fluidity and how it "allows your body to be immersed and held by the object" (fig. 12).[14]

Escobedo's Mar Tirreno residential project combines several of these strategies of deploying modular building elements and blending interior and exterior space (see pages 78–81). Rather than create a monolithic, vertical housing block, Escobedo split the residence into two separate volumes that flank an open-air patio corridor, offering a transitional space between the bustling street and the family home. Instead of having private balconies, each residential unit folds inward, turning in on itself to create quiet, sheltered terraces that offer a more ambiguous mediation between the interior and exterior. Similar to La Tallera, the intertwined spaces of Mar Tirreno are wrapped with an undulating facade of repetitive concrete breezeblock modules (fig. 13). The external walls appear, at first, solid, but—owing to the carefully angled brick openings—shift and dissolve as the occupant moves through the space. This effect is heightened further by the dramatic play of light and shadow rippling across the surface throughout the day.

TIME, DURATION, AND MEMORY

The day's progressing hours, as made manifest through the changing light that scatters across the exterior screen walls of Mar Tirreno, embody a concept at the heart of much of Escobedo's work: exposing and interrogating the passage of time. A key exemplar of this narrative thread is her Serpentine Pavilion, which she described as a structure that "could mentally and internally organize time and space" (fig. 14). The diagonal line that demarcated the shaded roof area and reflective pool was aligned to the Greenwich meridian, the historical calibration marker for international time and global trade. "This threshold," explained Escobedo, "emphasizes the sun's path. As the sun moves, the pavilion acts as a real sundial."[15]

More recently, in her design for the 2023 Artistic Annual Report for the Austrian lighting design company Zumtobel Group—a prestigious art book commission previously awarded to creatives such as Anish Kapoor, Olafur Eliasson, and Neville Brody—Escobedo continued her explorations of the lived histories of objects and materials

Fig. 9 Frida Escobedo Studio, Aesop Park Slope store interior, Brooklyn, 2019
Fig. 10 Frida Escobedo Studio and Mauricio Mesta Arquitectos, Niddo Café tiled wall, Mexico City, 2020
Fig. 11 Frida Escobedo Studio, *Chair 01*, 2017. Solid copper and copper plate, 29½ x 18⅛ x 18⅛ in. (75 x 46 x 46 cm). Private collection
Fig. 12 Frida Escobedo Studio, *Creek Chair*, 2021. Stainless-steel structure and nickel-ball chain, 32½ x 24 x 21½ in. (82.6 x 61 x 54.6 cm). Private collection
Fig. 13 Frida Escobedo Studio, Mar Tirreno terrace, Mexico City, 2018
Fig. 14 Frida Escobedo Studio, Serpentine Pavilion (conceptual study), 2018

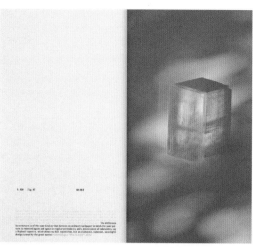

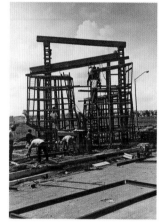
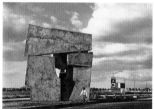
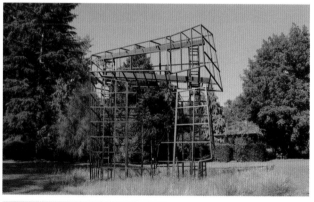

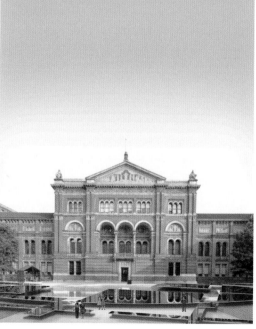
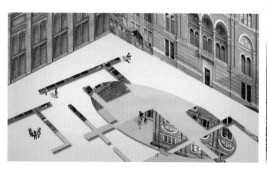

while also revisiting her interest in light, shadow, and the passing of time (figs. 15, 16).[16] Titled *The Book of Hours* (a reference to medieval prayer books and their recitation at fixed intervals of the day), this publication was a collaboration with Escobedo's two sisters—the photographer Ana Gómez de León and the poet María Gómez de León—to document twenty-four miscellaneous objects from her private collection. The photographs of these artifacts were taken at different periods of the day, in changing light conditions, capturing their transformations and their calibrations of time and space while also emphasizing the nature of contemplation in today's secular, productivity-driven approach to marking time.

In her *Estaciones* project, which emerged from her contribution to the 2017 Biennale d'Architecture d'Orléans, Escobedo also utilized photographic documentation as a tool to study the evolution of objects and structures. She became fascinated with the construction photographs for La Ruta de la Amistad (The Route of Friendship), a sequence of public sculptures commissioned for the 1968 Summer Olympics in Mexico City, which became symbolic of Mexico's modernist national identity set against a backdrop of social unrest and student protests (figs. 17–19). Conveying the notion of "political spectacle"[17] and exemplifying the artist Robert Smithson's conception of *"ruins in reverse,"*[18] these in-progress images captured the sculptures before their cladding was applied—frozen in a moment when their internal structures lay exposed, in an almost perilous state, while also resembling the utopian architectural proposals of the Russian Constructivists. Akin to Escobedo's own thoughts on how architecture can define the trajectories and accumulation of time, Smithson considered these types of structures as "the opposite of the 'romantic ruin' because the buildings don't *fall* into ruin *after* they are built but rather *rise* into ruin *before* they are built."[19]

Escobedo acknowledges the influence of the French philosopher Henri Bergson on her descriptions of how social calibrations of time can extend beyond abstraction and materialize spatially, reflecting a deeper social reality or truth. Bergson's theories explore *durée*, or "duration," within social space and how our internal perception of passing time

is often idiosyncratic and highly personal, compared to "objective" time as defined by clocks and watches. Many of Escobedo's buildings can be considered as manifestations of durational time, demonstrating what she describes as a "curiosity about how we define time and how architecture reflects it."[20] The "subtle traces of social time"[21] are visible in the anonymous facade of her *Split Subject* research, while projects such as *Civic Stage* (see pages 64–65) and temporary public installations at the Victoria and Albert Museum and the Museo Experimental el Eco enable a "process of creation and accumulation that happens slowly but steadily, so it becomes a continuous flow of happenings."[22]

PERFORMANCE AND PUBLIC PARTICIPATION

With Escobedo's installation for the Victoria and Albert Museum in 2015, the sense of a pavilion as a stage set was made explicit; a series of interconnected stage platforms with mirrored stainless-steel surfaces crept across the museum's garden courtyard, spanning both the grass and the central pool (see pages 70–73). Titled *You Know You Cannot See Yourself So Well as by Reflection* (an adapted line from Shakespeare's *Julius Caesar*), the installation's platforms reflected the adjacent museum facades and the visitors themselves, allowing the pavilion to absorb the activities of its participants and echo the textural qualities of the surrounding architecture (figs. 20, 21).

Escobedo's concept was centered around the "notion of wearing a mask"; the pavilion, she explained, "is an appropriation of a space and it changes the face of the space temporarily, like a mask. And that generates different characters, just like in theatre."[23] The project drew upon the history of modern-day Mexico City, which was built upon the ancient Aztec city of Tenochtitlán, which was itself built upon the vast Lake Texcoco. As her studio's project description puts it: "How to occupy a garden? Just like we occupied a lake."[24]

Escobedo has often cited the Mexican poet Octavio Paz's theories on the "mask," particularly its function as a tool for architectural expression and transformation. According to Paz, building facades—their *faces*—materialize character and perform a

Figs. 15, 16 Frida Escobedo (Mexican, born 1979), *The Book of Hours* (Dornbirn: Zumtobel Group AG, 2023), pp. 20–21 (left), 70–71 (right), showing colorless calcite at different times of day
Fig. 17 Construction photograph of *Station #16*, (*Estación #16*), sculpture by Olivier Seguin (French, born 1927), Mexico City, 1968
Fig. 18 Olivier Seguin, *Station #16*, (*Estación #16*), Mexico City, 1968
Fig. 19 Frida Escobedo Studio, *Estaciones* (*Estación 16*), Orléans, France, 2017
Figs. 20, 21 Frida Escobedo Studio, *You Know You Cannot See Yourself So Well as by Reflection* (digital collages), 2015

22, 23

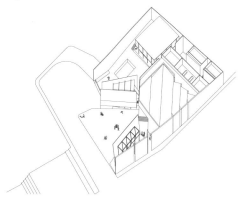

24

25, 26

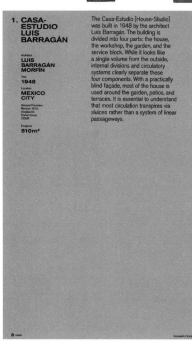

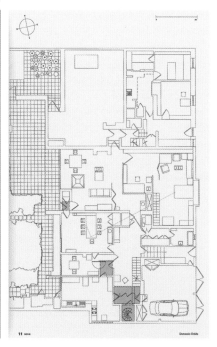

1. CASA-ESTUDIO LUIS BARRAGÁN

Architect
LUIS BARRAGÁN MORFÍN

Title
1948

Location
MEXICO CITY

General Francisco
Ramírez 12-14,
Ampliación
Daniel Garza,
CDMX

Footprint
510m²

The Casa-Estudio [House-Studio] was built in 1948 by the architect Luis Barragán. The building is divided into four parts: the house, the workshop, the garden, and the service block. While it looks like a single volume from the outside, internal divisions and circulatory systems clearly separate these four components. With a practically blind façade, most of the house is used around the garden, patios, and terraces. It is essential to understand that most circulation transpires via sluices rather than a system of linear passageways.

function similar to how we in society "perform" our social faces, deploying the mask "on one hand as a shield, a wall; on the other, a symbol-covered surface, a hieroglyph."[25] Paz describes the mask as a threshold between the self and the other, which Escobedo interprets as a compounding, layered configuration: "Each preceding layer unfolds into the next, and each new layer builds a new narrative of all the previous ones." Escobedo's pavilion uses this concept of the mask to present a "liminal zone that weaves together two different identities"—that of contemporary Mexico City and that of ancient Tenochtitlán—spanning centuries and diverse cultural contexts to make "room for new forms of representation."[26]

For her 2010 pavilion for the Museo Experimental el Eco in Mexico City, Escobedo covered the museum's courtyard with a blanket of stacked cinder blocks, creating a dramatic—and participatory—intervention that treated the space like the expanse of a blank page, with the concrete blocks acting like elements from a structural alphabet (see pages 54–57). The blocks were not fixed in place, allowing museum staff and visitors to reassemble them—either freely or into predesigned functional configurations (with names like "meadow," "labyrinth," "forum," and "bar"). This was Escobedo's first project that allowed her to engage with the notion of the single unit multiplied and replicated at scale, exploring the tension between individuality and collectivity.[27] As she has stated, "At first glance, a brick is a rigid industrial piece. . . . Yet, when people appropriate it, the expressions are infinite."[28]

SOCIAL AND SPATIAL HISTORY
Escobedo won her first major architectural competition for the renovation of La Tallera, which was also her first public building and a commission that explicitly provoked questions around the passing of time, cultural memory, and the transformations of communal architectural spaces. Previously, the site included two immense murals by Siqueiros, located within an external courtyard, that had faced inward for many years. Escobedo treated these murals like scenery flats, rotating them outward to face a newly expanded public plaza (figs. 22, 23). Describing this design move as an "unfolding of space," Escobedo compares these pivoted murals to the

geometric panels and hinged joints of Lygia Clark's *Bicho* sculptures (fig. 43),[29] scaling up the power of these transforming objects to provide an architectural strategy for the new civic space at La Tallera.

Escobedo's studio is currently working on a similar adaptive reuse project in the Mexican city of Puebla, where the history of the site and careful material choices are key to the reactivation of communal spaces. The Avenida Juárez project involves the conversion of a dilapidated late-nineteenth-century courtyard house into a new hotel and wellness retreat and forms part of a wider renovation of a historic avenue that was once the center of the city's commercial and cultural life (see pages 114–15). Tackling the question of how the history and character of a place can be preserved despite contemporary additions, the studio decided to combine sensitive restoration with "acupunctural intervention."[30] Rare surviving elements from the historic house, all rendered in volcanic basalt stone, provided the material language for the new interventions. Most notable among these is a dramatic staircase that spirals upward through the building, culminating in a monolithic enclosure that ushers visitors onto the roof terrace (fig. 24).

Escobedo's interest in the material and social histories of architectural spaces, and their potential (re)activations, can also be seen in *Domestic Orbits*, a speculative essay from 2019 exploring architecture's tendency to conceal spaces of domestic labor (figs. 25, 26).[31] Coming shortly after the release of Alfonso Cuarón's Oscar-winning *Roma*, which touched upon similar themes, Escobedo analyzed the plans of five modern structures in Mexico City, including the iconic Casa Luis Barragán, with the assistance of Harvard GSD students. Her investigation demonstrated how the design of these buildings systematically excludes and "erases" spaces of labor by keeping domestic workers in spatially distinct domains from the "public" areas of the house—nesting their hidden households within the main household, or relegating them to inferior ancillary buildings. The essay, accompanying diagrams, and underlying research expose how this "selective concealment of domestic space makes [architecture] complicit with great social inequities associated with gender, class, and race." This project, like *Split Subject*, reinforces and

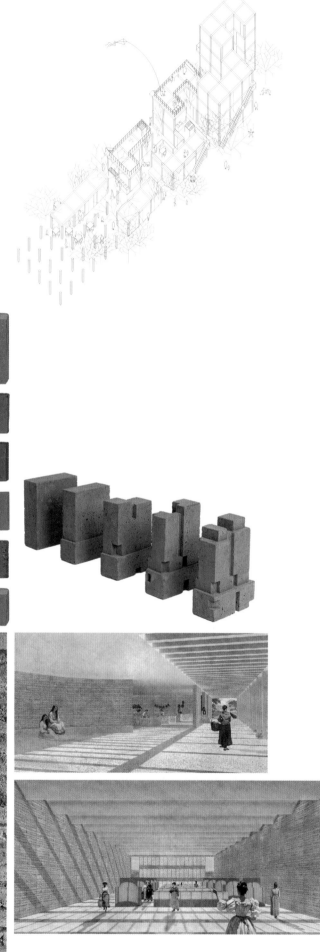

informs Escobedo's architectural practice; she states that her studio's work is rooted in "the idea that architecture and design represent a crucial means of posing questions and contesting social, economic and political phenomena."[32]

COMMUNITY NEEDS

Escobedo's residential projects have often demonstrated a fundamental focus on community and an attentiveness to a contemporary society with rapidly shifting economic, social, and cultural needs. Among these are designs for several social housing projects for INFONAVIT, Mexico's national institute for worker's housing, in response to rural housing, historic renovation, and redensification initiatives (fig. 27). Her studio is currently collaborating with Handel Architects on Ray Harlem, a building that will combine a large-scale multifamily residential project with a renovated performance space for the culturally vital National Black Theatre (see pages 116–17). Escobedo's plan allows the theater to project into the street via selective cut-throughs in the residential facade and creates new spaces for community gathering and programming throughout the complex.

Escobedo and her studio are also conscious of the profound impact of the construction industry on the climate crisis, and of the need to find sustainable design solutions within their projects. Acknowledging the prominent use of modular building blocks in many of their commissions, Escobedo's team has been working on making these brick units more efficient and, crucially, more environmentally responsible, by seeking out alternative materials (figs. 28, 29). For a forthcoming distillery project for Yola Mezcal (see pages 118–19), her studio is using a new adobe brick, developed by COAA Asesores and Gnanli Landrou, that combines local soil with converted residue from the acidic and polluting waste of the fermentation process and fibers from the agave plant itself (fig. 30).

The project also addresses gender inequities. Yola Mezcal is one of very few women-owned mezcal companies, and the company hires only women to distill, bottle, and sell the finished product. Recognizing that this commission goes well beyond a mere industrial project, Escobedo sees how that this new model for construction and employment will have a significant impact on multiple communities in the region of production. Further—and with an awareness of the "double duty" that many women endure when they return home to household tasks after work—the project will incorporate a childcare facility, a communal orchard and kitchen, and a safe space for victims of domestic violence (figs. 31, 32).

AN EDIFICE OF TIME

Previously, Escobedo has compared architecture to language, stating that "language is not a closed or predictable system," but rather "absolutely individual, unpredictable and accidental . . . built upon the additions, translations, substitutions, and subtractions that occur through its use."[33] Similarly, when explaining her own approach to architecture, she has stated, "I don't believe in finished buildings. I think it's always an open work of art."[34] This philosophy seems to capture several lines of inquiry within her practice, from the transformation of materials and the passing of time to her deeply held belief in architecture's role in defining and responding to social conditions and community requirements that are in constant flux. For Escobedo, the transitory nature of architecture is indicative of greater connections across time: "The past reappears because it is a hidden present . . . something that [took] place but [did] not wholly recede."[35] At the end of her competition-winning presentation for The Met Tang Wing commission, she described her practice as "unearthing historical, social, and geological layers . . . where stratification is exposed and provoked, challenging the power relationships between people, space, and matter."[36] She has taken on a challenging, but thrilling, brief to create a new home for modern and contemporary art that situates itself within a vast collection that spans centuries, geographical and cultural contexts, and object types—offering visitors new narratives that allow the present to be reflected in the past, and vice versa, while also allowing the Museum to examine its own history. She concluded the talk by expressing the hope that the new wing for The Met will resonate with Paz's description of the Mesoamerican pyramid as an "edifice made of time: what was, what will be, what is."[37]

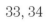

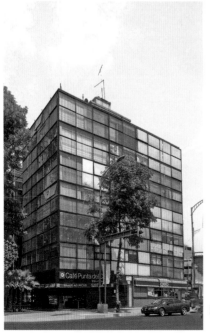

I like to think of architecture as a language.[1]
—Frida Escobedo

Frida Escobedo understands architecture as a spatial practice that is at once expansive and situated. Her approach to an architectural context, a commission, or a research proposition reveals a constellation of connections and references with which she is in conversation, and which help her to materialize ideas in space: conceptual anchors that interact with the universe of the sensible. Having grown up in Mexico City, she draws upon concepts from her personal experience that play a fundamental role in her creative process and that are embodied in her practice. This is the case for fluidity or interconnection, notions of which she speaks often and which are rooted in her observation of—and lived experience in—a metropolis of great contrasts and tensions, with a special creative energy deriving from its different forms of spatial appropriation and use. In Mexico City, pre-Hispanic ruins, colonial buildings, and modern and contemporary developments live side by side, making the city into what she calls "a living and breathing museum, full of layered stories from different time periods woven together."[2]

From this perspective, Mexico City informs Escobedo's practice in various ways, both conceptually and through the use of particular materials or architectural types. Yet the influence of geography connects to much more: "My perspective . . . emerges from a specific intersection of gender and geographic origins."[3] As a Latin American woman working at a multitude of different latitudes, Escobedo brings specific questions to the conversation. Even so, it is useful to consider the perspective of the writer Adrienne Rich, speaking on the interpretation of her work: "If you ascribe each event to some actual event, if you ascribe each image, each relationship to some literal occasion, it seems to me that you run the risk of missing not only the poetry, but the fuller, richer, deeper aspects of the poems, which come not necessarily from the poet's biography, but from what the poet has seen, heard, drawn into herself or himself from other lives."[4]

What Escobedo has seen, heard, and drawn into her work includes ideas from—and dialogues with—figures such as Lina Bo Bardi, Lygia Clark, Mathias Goeritz, and Ana Mendieta, among others. These touchpoints become, consciously or unconsciously, a kind of artistic lineage for Escobedo and extend to a way of thinking in conversation with a multiplicity of references that come from art, literature, and theoretical thought. In this context, the relationship that Escobedo establishes between architecture and language is a fertile analogy for thinking about not only the links between the production of space and the construction of narratives but also about the interpretation of such spaces and narratives. This interpretation includes the experience of a space and sheds light on notions like translation, poetry, and the limitations of expression. How is space to be read? Why does an arrangement of words or of elements in space say one thing and not another? What are its specific affordances? These are questions that are incorporated into Escobedo's work and into the collaborative work of her studio.

Once more, Rich provides a concept relevant to Escobedo's oeuvre with the title of her 1993 collection of essays on the personal and the collective: *What is Found There: Notebooks on Poetry and Politics*. The phrase "what is found there" can serve here as a potent and poetic anchor for discussing what connects Escobedo's gaze with context and place, a way of approaching the notion of site-specificity in her work. Noting *what is found there*—observing, recording, intuiting—is central to her creative process, which formulates questions in order to begin to read a story and understand what it might say about social dynamics, economic flows, familial or affective connections, and the visible and the invisible. In this sense, every project is a distinct problem, and the way in which each materializes largely depends on what is found there.

Escobedo's production covers a wide spectrum of scales and formats that range from residential, commercial, hospitality, and infrastructure design; to temporary architecture for public programs; to exhibition design and objects. Running parallel to all these projects is artistic and research-based work invested in themes that are relevant to her practice—like, for example, the long-term project *Split Subject*, in which she investigates the relationship between national identity and Mexican modernism by deconstructing the facade of an anonymous building in Mexico City (fig. 33; see pages 62–63), or the speculative essay *Domestic Orbits*, which questions the relationship between architecture and domestic labor in Mexico. Her diversity of

Fig. 33 The building facade studied by Escobedo in *Split Subject / El Otro*, ca. 2012
Fig. 34 Lina Bo Bardi (Brazilian, born Italy, 1914–1992), Museu de Arte de São Paulo, built 1968.
 By elevating the museum building, Bo Bardi created a public square beneath it.

35

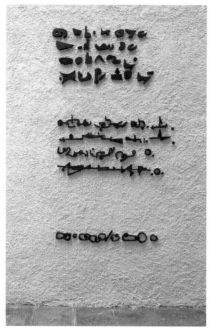

36, 37

1

2

3

4

5

6

38

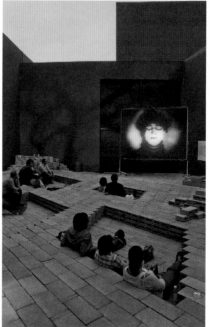

production brings to mind the radical sensibility of the Brazilian architect Lina Bo Bardi, with whom she shares a generous and highly personal vision of the possibilities of creating spatial situations with a social purpose—a way of establishing the conditions for something to happen (fig. 34).

Both Bo Bardi and Escobedo rely on a simple formal vocabulary in their strong design concepts. Bo Bardi's works are truly experimental; she approached exhibition design and built spaces as forms that can nurture collective life and foster meaningful experiences that make new manners of interaction possible. Escobedo shares her understanding that the production of space does not necessitate designing and constructing that space from scratch, or completing a built work. Architecture often emerges in a dialogue with what already exists in a space or as a response to it, and in that sense, the practice is associated with what Bo Bardi considered "the theater of life," the relationship that we, as humans, establish with the built environment.[5]

Some of Escobedo's most visible work so far has consisted of projects of a temporary nature; these are realms in which she moves fluidly. Projects of this type range from invitations to design an object, an installation, or a pavilion for a museum to the opportunity to intervene in a public plaza as part of a biennial. They act as a kind of laboratory for spatial reflection and experimentation within a specific framework with well-defined rules. Such projects operate on a different scale to plans for large permanent constructions, and some of them have a short life. Nevertheless, they are important stimuli for the development of Escobedo's ideas and the generation of spaces with particular conceptual grounding.

One of Escobedo's most emblematic projects, and one that was pivotal to her early career, was the 2010 pavilion at the Museo Experimental el Eco in Mexico City (El Eco; see pages 54–57).[6] This project, moreover, engaged with many of the ideas that were further developed in later years and continue to inform her practice. The brief was to create a temporary intervention for public programming in the patio of the museum, which was constructed in 1953 by the German artist Mathias Goeritz under the premise of "emotional architecture."[7] When Goeritz designed the building, he thought of it as an architectural work that would become sculptural and a sculptural work that would become a construction—in short, a habitable sculpture—drawn from a blend of European references, including the Cabaret Voltaire, German Expressionism, and ideas originating in the Bauhaus, as well as local referents such as pre-Hispanic architecture and cosmogony.[8] The focus was on understanding the site as an experience and displaying its openness to artistic endeavor.

Escobedo's proposal for the patio of El Eco succeeded in establishing a dialogue between the interests of the museum as a space dedicated to contemporary artistic production and its history as a visionary space devoted to experimentation. This was achieved through a link with Goeritz's interest in concrete poetry, an international movement that began around the same time as El Eco was built. Understood as a visual and conceptual practice in which "language is used as a material rather than as a personal means of emotive expression,"[9] it appeared simultaneously and separately in Switzerland and Brazil in 1953 and emphasized the visual aspect of language. Goeritz was linked to the movement from the start and was its only representative in Mexico at that time (fig. 35).[10]

Making reference to writing and to the way words can be regarded as blocks that construct sentences, Escobedo proposed using a single material to "generate a support that would allow the programmatic possibilities of the courtyard to be extended on the basis of the repetition of a single element: the gray concrete cinder block" (fig. 36).[11] The courtyard was thus covered with a surface of loose gray building blocks—an affordable and popular material found in abundance in Mexico City and its surroundings (fig. 37)—which could be moved around to form new configurations, either by the museum staff as needed for public programs (talks, concerts, film screenings; fig. 38) or by visitors as they wished. This changing floor was always at the disposal of those at the museum, who could decide to cross it, modify it, or even take some of these pieces to do something with them elsewhere: a play of expansion and contraction. Above all, however, it was an activation of the space through the relationship between words and material—literally concrete poetry, in action and in construction.

39, 40

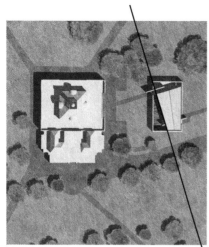
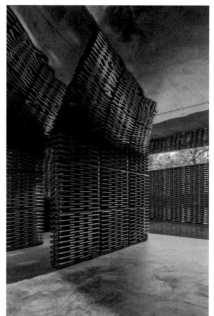

41, 42

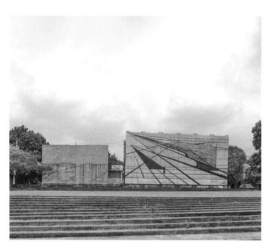
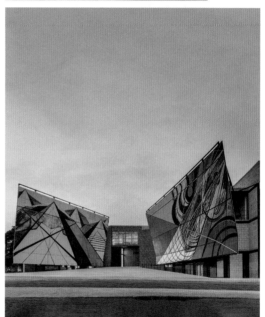

43

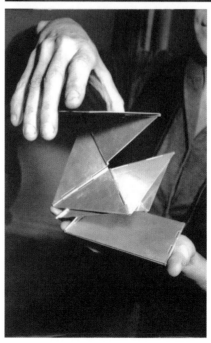

At the opening of the museum, in 1953, Goeritz read his manifesto of emotional architecture, which begins: "The new Museo Experimental el Eco, in Mexico City, begins its activities, meaning its experiments, with the architectural work of its own building. This work was envisaged as an example of an architecture whose principal function is emotion."[12] These ideas arose in fierce opposition to the functionalism of modern architecture and the manner in which he considered logic and utility to have dehumanized architecture.[13] Central to Goeritz's program of emotional architecture is the notion of creating a "living institution, a place in which whoever felt the need to carry out a bold artistic project could do so."[14] Its changing nature is the result of a proposal that is open enough to allow its transformation, something that echoes Escobedo's similar interests regarding the programmatic possibilities of a space. Escobedo created a living pavilion that conversed with Goeritz's ideas on experimentation and with the historical context of concrete poetry, proving that *what is found there* is much more than the physical structure of a place.

In 2018, Escobedo was invited to design the Serpentine Pavilion in the Kensington Gardens of London, an annual commission initiated by the Serpentine galleries in 2000 and without doubt one of the most interesting forums worldwide for spatial reflection (see pages 82–85). For this pavilion, Escobedo and her team proposed a connection with the site based on the park's proximity to the Greenwich meridian, the imaginary line connecting the Earth's poles that has historically been used for measuring global longitudes and, therefore, time (fig. 39). The layout of the pavilion alludes directly to this, while the structure is made of the gray tiles characteristic of British architecture, used here to create latticed walls. This gives rise to an interplay of light and shadow that makes the structure less weighty, offering space for the individual gaze or for the discovery of other gazes. Escobedo has a way of using materials that dispenses with finishes and thus displays their intrinsic characteristics, a way of honoring the material while also using it in ways distinct from its original use (fig. 40).

Every year, the pavilion is moved at the end of the summer to a new location, which may be a public or a private space depending on who acquires it. This especially interested Escobedo and became central to her design, a reflection on what enables architecture to form a relation with a site. Here, the idea led her to speak of a "site-less" pavilion,[15] simultaneously situated in and freed from the site-specific condition as it moves through longitudes but always maintains a relation with the Greenwich meridian at the longitude of zero. Regarding this project, the architect and theorist Marina Otero Verzier wrote: "The liminal condition of architecture is, therefore, not only enacted by built structures, but also by the historical, material, social and political systems that erect or erode them. In building an enclosure with an enhanced interiority whose limits depend upon the changing conditions of time and space, light and shadow, wind and rain, as well as processes of assembly and disassembly, Escobedo also refuses any understanding of architecture as a fixed stage of human events."[16]

Through her play with the latticework of a material like the tiles in London or the blocks used at La Tallera—the former studio and residence of the Mexican muralist David Alfaro Siqueiros—it is evident that Escobedo has a clear understanding of light's ability to transform a space. She uses light and shadow like mobile writing, in such a way that their different rhythms, arrangements, and textures create visual fields that manage to stand out in a greater landscape. Many of her works are based on a potent but subtle gesture that transforms perception, as in the case of La Tallera (see pages 58–61). Here, Escobedo was invited to restore the artist residence and studio with the aim of opening it to the public as a space dedicated to contemporary art.[17] The building contained two large murals by Siqueiros that became the key element of Escobedo's dialogue with the site. She suggested rotating them from their original position to open them onto a facing square at an angle that created, at the same time, a corridor and a new facade (figs. 41, 42). This simple gesture became a powerful movement that changed the building's relationship with the exterior and the relationship between La Tallera and its visitors, helping to reinforce the purpose of the space while also linking the new configuration of its architecture to the muralist's social concerns as they affect the present day.

Fig. 39 Frida Escobedo Studio, Serpentine Pavilion, London, 2018 (at right), with the Serpentine South gallery to the left. The diagonal line running parallel to the pavilion's roof represents the Greenwich meridian.

Fig. 40 Frida Escobedo Studio, Serpentine Pavilion interior, London, 2018

Figs. 41, 42 La Tallera, Cuernavaca, Mexico, before (left) and after (right) Escobedo's 2012 renovation

Fig. 43 Lygia Clark (Brazilian, 1920–1988), *Bicho de bolso* (*Pocket Animal*), 1960/66. Aluminum, variable. "The World of Lygia Clark" Cultural Association, Rio de Janeiro

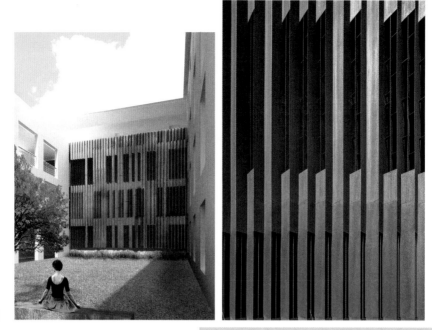

44, 45
46

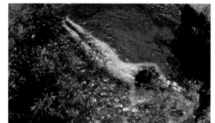

47, 48

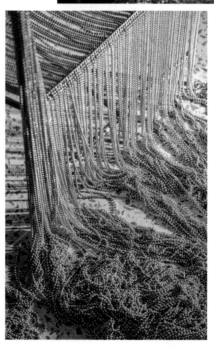

When Escobedo presents or discusses her projects in public, she usually accompanies them with images of works by artists who interest her. One is the Brazilian artist Lygia Clark, whose work is highly significant in terms of thinking of sculpture—or architecture—as a living organism. Clark's *Bichos*, developed under the ideas of Neo-Concretism, are metal sculptures of geometric planes joined by hinges that create new spatial situations when manipulated (fig. 43). They are interactive sculptural compositions that are forever changing, thus eliminating the distance between the spectator and the artwork. For Escobedo, architecture is always unfinished: "Everything is always becoming something else, not just architecture, but people, language, etc. When I realized this, it was really liberating: work does not need to be perfect and permanent as we are taught in architecture school. What does permanence even mean?"[18]

At La Tallera or the Serpentine Pavilion, it is the transparency of the lattice that determines the experience of the space, whereas in Escobedo's art installation *A Very Short Space of Time Through Very Short Times of Space* (see pages 74–75), commissioned for a residence at Stanford University, it is the relationship between sound and body that transforms the relationship with the space. The structure, a metallic screen with movable elements, produces sound when touched by any person who chooses to activate it (figs. 44–46). This carefully considered relationship between the qualities of materials and the body can also be seen in furniture design projects such as *Creek Bench*, which was designed in response to an invitation from MASA Galería to engage in dialogue with the work of the Cuban-born artist Ana Mendieta, known for her strong performative interventions within nature. Escobedo's series that emerged from this invitation refers directly to the 1974 film *Creek*, in which Mendieta submerges her body in a creek in Oaxaca, Mexico, making her temporary presence in the environment evident by becoming part of the landscape (fig. 47). The chair and the bench in this series are made of chains that leave their mark on the skin of the body whose weight they support, bearing testimony to the changing existence of both (fig. 48).

The relationship with language maintained by Escobedo's work connects with emotion through the highly personal aspects of language while simultaneously opening up the potential for togetherness, imagination, and collective knowledge. If architecture is a language, for Escobedo the opportunity is not only to employ a language that we know and use individually but also to discover the shared experiences that language creates.

Fig. 44 Frida Escobedo Studio, *A Very Short Space of Time Through Very Short Times of Space* (digital collage), 2016
Fig. 45 Frida Escobedo Studio, *A Very Short Space of Time Through Very Short Times of Space*, Palo Alto, 2016
Fig. 46 Frida Escobedo Studio, *A Very Short Space of Time Through Very Short Times of Space* (conceptual study), 2016
Fig. 47 Ana Mendieta (American, born Cuba, 1948–1985), *Creek* (still), 1974. Super-8mm film, color, silent
Fig. 48 Frida Escobedo Studio, *Creek Bench* (detail), 2021. Stainless-steel structure and nickel-ball chain, 70⅞ x 22 x 32⅝ in. (180 x 56 x 83 cm)

49

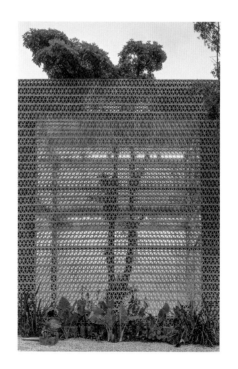

Frida Escobedo is profoundly attuned to how architecture shapes public perceptions of art. Her work is defined by a commitment to the civic uses of design and a keen attention to materials and light. As the architect of the Oscar L. Tang and H.M. Agnes Hsu-Tang Wing of The Metropolitan Museum of Art, which will house modern and contemporary art upon its completion, Escobedo is poised to transform the experience of millions of annual visitors to one of the world's most beloved museums.

This task is not without its challenges. The mission of an art museum like The Met is to welcome thousands of people to experience countless artworks every day while still creating the conditions for intimate encounters with individual works within its galleries. This calls for a fine balance between individual and collective experiences. How can the architecture and design of a museum serve this mission and complement the artworks it houses?

Escobedo's solution to these challenges is not, as she has said, "about transparency, where you see everything right away." Instead, she is drawn to porous designs and materials (fig. 49), explaining: "Porosity allows mystery. There are other layers, moments of invitation, moments of slight distance, moments of engaging you or forcing you to become more focused."[1] Porosity, layering, invitation, and distance—these are concepts that drive Escobedo's architectural practice.

While moments of distance and invitation may seem at odds, their coexistence is essential to addressing the tension between shared, public experiences and individual, private engagement with artworks. Porous boundaries and schemes of organization offer structure and opportunities for solitary reflection, where each object, Escobedo explains, "becomes a universe in itself"[2]—but they also allow for easy movement between artworks and ideas. The adaptability of Escobedo's vision is evident in her temporary installations and her past work in exhibition design, which deploys space, light, and materials to set the stage for intimate encounters with art in communal spaces (figs. 50–52).

This layering of seemingly paradoxical concepts is aligned with The Met's aim to present visitors with a long and interconnected art history. The Met displays art from all over the world in the context of thousands of years of human creativity, resulting in what Escobedo describes as a "larger tapestry or collage of how we understand

50, 51

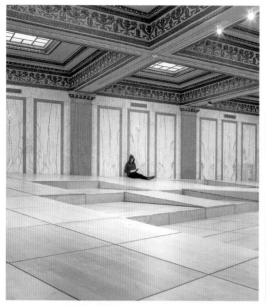
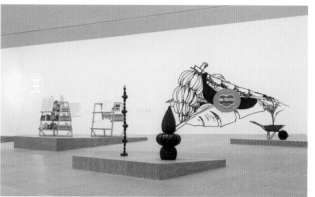

52

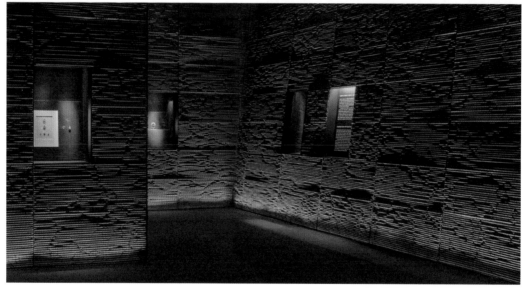

53

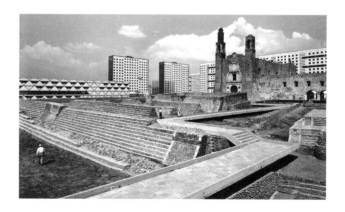

human culture."[3] The Museum's collection consists of all different media and artistic articulations—from paintings, sculpture, drawings, and photographs to textiles, musical instruments, and arms and armor. Within such a gathering of art forms, there are layers of meaning, of overlapping and intermingled ideas, of contradictions and contrary notions.

That Escobedo's hometown is Mexico City—where ancient American structures sit beneath colonial buildings that are, today, incorporated into the modern urban infrastructure—makes her especially sensitive to such pluralism. "Mexican architecture is an architecture of layering," she has said (fig. 53).[4] Her architectural practice is informed by chronological and cultural multiplicity, a defining characteristic of an encyclopedic museum collection.

With its convergence of styles and designs, The Met's Fifth Avenue building is a fitting home to such a collection. As visitors travel through the galleries, they navigate a building designed by more than a dozen architectural firms since 1874. From the columns, domes, and arches of Richard Morris Hunt's neoclassical Beaux-Arts Great Hall to Kevin Roche John Dinkeloo and Associates' light-filled, slanted-glass enclosures facing Central Park, the Museum's collection is presented in a structure that reflects more than 150 years of architectural approaches—a synchronicity of perspectives that reflects, in microcosm, the diversity of the works it holds.[5] Escobedo's layer in this palimpsest will be shaped by her appreciation for the material history of the existing building, but it will also seek to highlight more transhistorical and cross-cultural connections.

Escobedo's design for the future Tang Wing recognizes that modern and contemporary art builds a bridge from the past to the present and engages the larger context of the Museum and its collection without being limited by restrictive categories of chronology and nationality. Her approach, with its focus on flexibility, layering, and porosity, allows for more creative displays of the correspondences—and distinctions—between times, places, and media. This is essential in an era of increased global interconnectedness and sociopolitical polarization. As nationalism proliferates, art can stand for our shared humanity.

Escobedo is the first woman to design a wing for The Met, and her architectural approach corresponds to the Museum's mission to offer a nuanced, inclusive, and multicultural vision of art. The Tang Wing will benefit from her characteristic attention to communal experience, which she considers in tandem with the socioeconomic and ecological issues of our time. From her research on the architectural tendency to conceal labor, particularly domestic labor, to her awareness of the social dynamics embedded in local building materials, Escobedo's perspective is informed by her continual inquiry and exploration of ideas related to gender, geographical origins, accessibility, and the environment. Her work challenges embedded hierarchies of history and prioritizes the fruitful, enlightening interactions that happen wherever people come together.

When reading the four interviews with Frida Escobedo that follow, I started to think of the concept of polyphony. It's an idea that has its roots in music, signifying two or more melodic lines, equally prominent, playing at the same time. The beauty is that each is a melody in its own right; the miracle is the complex serendipity when independencies become newly contingent and interwoven. The philosopher Mikhail Bakhtin borrowed the concept to describe the radicality of Dostoevsky's prose, in which unmerged voices remain that way, freed of the expectations of unity, where distinction and difference are implicitly flattened. In this narrative mode, there is no erosion of messy specificity.

Messy specificity—enrapturing, dynamic, and multiple—is exactly the context in which Escobedo finds herself at The Met, a gloriously sprawling institution that she frequently refers to as a medieval city. These four interviews, conducted by the department heads of, respectively, Capital Projects, Drawings and Prints, Photographs, and Modern and Contemporary Art, suggest the range of constituents, values, and perspectives involved in the realization of the Oscar L. Tang and H.M. Agnes Hsu-Tang Wing, The Met's future home for modern and contemporary art, which will be located at the southwest corner of its campus.

The interviewers here, along with scores of other colleagues, are also the primary and regular collaborators with Escobedo and her studio in this process. While driven by similar values—fundamentally, a belief in the power of art and artists to transform lives and the centrality of art to daily and civic life—we represent collections with different histories and needs, varieties of tastes and predilections, as well as a diversity of experiences and backgrounds that led us here. Escobedo's great challenge and greater opportunity at The Met is not to unify these differences but channel them into meaningful, consonant, rhythmic spatial propositions.

The metaphor of weaving is a frequent and telling leitmotif in Escobedo's interviews as it suggests entanglements of ideas rather than discrete epiphanies. These entanglements are where time, materiality, and attention to location yield a sense of history that is as dynamic as it is porous. In her interviews with both Jeff L. Rosenheim and me, she brings these points together with her characteristic rigorous clarity. I will string her comments into a single quotation as a nod to how weaving works in her practice: "We are pulling threads of history and thinking about what the continuities should be, and about how to create different textures or landscapes that allow those threads to be read in different manners as you move through space. . . . The intention is for it to be creating, in some moments, continuity, and in other moments, reflection. Looking back and seeing all these different layers that have been formed at different moments in time. And then, hopefully, emerging to see where we're standing now."

One of the most important aesthetic breakthroughs of the twentieth century—one with both political and spiritual implications—had its origins in John Cage's experience within an anechoic chamber in Cambridge, Massachusetts, in 1951. In a subsequent lecture, he described his experience: "In that silent room, I heard two sounds, one high and one low. Afterward I asked the engineer in charge why, if the room was so silent, I heard two sounds. He said, 'Describe them.' I did. He said, 'The high one was your nervous system in operation. The low one was your blood in circulation.'" The next year, Cage composed his famous piece *4'33"*, in which a pianist sits at the piano for four minutes and thirty-three seconds, doing nothing. Cage's contention was that all the microsonic accidentals—those incidental events that surround us—are actually the elements that constitute life. The performance itself can be the distraction from the importance of the periphery.

Escobedo has a similarly poetic and political relationship to architecture when she invokes the Japanese term *ma*, which she describes as "the space between things." She situates this—designing the space between things—as central to her architecture, affecting "the way that you're receiving the in-between space, that void, that suspended moment that you keep in your memory. I think it's the suspended moment that is the main goal—that's the design proposition. It's not the building itself, it's the suspended moment." Of course, it *is* the building that will permit these moments of suspension. But without the conversations that will result in the building, only a minute sampling of which is reflected in this book, there is no humanity, no history, no art, no silently whirring nerves and blood that translate mere structure into architecture. This is the polyphony that Escobedo plays.

—David Breslin

JHAELEN HERNANDEZ-ELI: I find it really interesting to hear where people came from. So I thought we could start by talking about your formative years and your family.

FRIDA ESCOBEDO: Well, I was born in Mexico City. My dad was also born in Mexico City, and my mom is from Tijuana, but she moved around in her childhood before settling in Mexico City. My mother is a sociologist.

JHE What was her job when you were growing up?

FE She started at the Secretariat of Programming and Budget, then she worked on the Mexican census, and after that she worked for UN Women. She had a mentor there, the head of the Latin American division, who was very influential to me when I was little. My first trip outside the country was to New York when I was nine, and we stayed in her apartment. That was a life-changing experience: seeing this woman so free, living in this tiny studio apartment, making significant changes for people. I thought she was wonderful.

JHE When I reflect on your projects about domestic and back-of-house spaces, I'm curious if such work is informed by your experiences with your mother.

FE Definitely. We're always discussing the way people live, and why they live the way they do, and what is not being considered when people plan spaces.

JHE And your father, how did he influence you?

FE He's a doctor, an obstetrician. The way that he interacts with people is very healing and nurturing, and babies just are drawn to him. At some point in his career, around the time he and my

mom divorced, he had to decide whether to go into private practice. He chose to stay in public service and spend time with me, which I'm really grateful for.

JHE What did you two do?

FE We would go to piano lessons, to the park, to the museum. Basically it was just a normal, domestic life. I think I was lucky to have that vision of a hardworking mother who traveled and was very involved with her work, and a father who was very thoughtful about the way he was taking care of me and helping me grow. I think that's uncommon in my generation.

JHE Right. Now let's fast-forward to the commission at The Met. I'd love to hear about what being on the shortlist meant to you, and what the proposal process was like for you.

FE It felt a little bit intimidating, of course, but that's how all the major changes in my career have been. I never worked for another studio, so I never worked with someone who had more experience than me. I always had to prove myself and to work hard to arrive to that level.

So I thought, well, maybe they need someone on this list who's younger, from a Latin American context. Sometimes it feels like: Is this a test, you know? And I talked with the team about

Fig. 54 Robert Smithson (American, 1938–1973), *A heap of Language*, 1966. Pencil on graph paper, 6½ x 22 in. (16.5 x 55.9 cm). The Museum of Modern Art, New York (1720.2015)

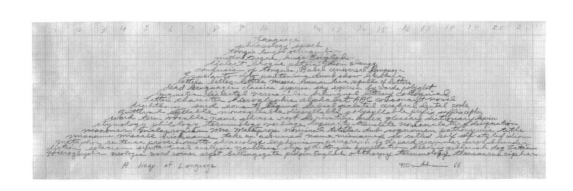

it—like, what are the actual chances that we get this? But we had nothing to lose. We just decided to do all that we could—put all our energy, all our resources into it.

The process was really interesting, because I don't think I've ever had the chance of collaborating and building a relationship of trust from the competition moment. I think that was smart and helpful—building trust on one side and confidence on the other.

JHE It allowed us to nurture a relationship. You are such a fabulous collaborator and listener—but that's not to say that you don't have a point of view. So let's talk about that. What is architecture to you?

FE I think it's a language. It's a way of communicating things, and understanding the world, and understanding how people interact. It's a projection of desires and a representation of values (fig. 54).

JHE What do you think architecture is dealing with right now?

FE Well, we're taught in architecture school that we determine how people live, but we actually come at the very end of that process. If we don't start thinking that the way we define space starts much earlier, we're just decorating.

JHE Making manifest someone else's values, or whatever system is in place.

FE Yes. So we need to start thinking that design is not just materials and proportions; it's designing programs, designing financial structures, designing zoning, all of these things that have an impact on how we shape a space.

JHE Are there challenges that you are particularly interested in addressing as an architect?

FE One of the things that we could always consider, no matter what part of that long process we're in, is everyone who's going to be living in that space. That includes people who are not necessarily paying for the project. What we build has an impact on so many other publics.

JHE What we build also has an impact on the environment. What do you think architecture's role is in addressing the climate crisis?

FE This is a complicated issue. Construction is one of the most contaminating industries on the planet. As architects, we have an opportunity to push boundaries and encourage our clients to be bolder and more progressive.

At The Met, it's especially important because of the high visibility that the Tang Wing will have. We can set an example for others.

JHE With the Tang Wing, are there specific opportunities to implement sustainability?

FE I think one of the opportunities for experimentation is reusing elements, whether architectural features or even materials from the existing wing. For example, we've been discussing how to recycle fragments of the facade.

JHE I'm curious, do you aestheticize your strategies? Make them expressive, explicit, noticeable?

FE I'm not particularly interested in the architecture announcing our sustainability strategies. Sustainability is a way of thinking for me (fig. 55). I'm interested in the expression and genuine humbleness of environmentally friendly materials, but not necessarily in making a statement.

JHE How will the new wing acknowledge and challenge how museums display contemporary art?

FE I think museums today aim for flexibility, which is an interesting challenge because, of course, then you have to be neutral. How can we imagine a space for pieces that are not yet created?
 I think it's important to have some specificity. The most beautiful buildings do that. They speak to their time and how they were constructed.

JHE What kind of space would you point to as a space of neutrality? Would it be fair to say, for example, the white box?

FE That's right. The white box. It's a good example because it feels like it's neutral, but at the same time it's very flattening. There's this illusion that, well, that sort of space creates the perfect conditions for artwork, but I don't think artists think that they're going to be in a blank environment.

JHE What is your response to folks who say, "I want the attention on the piece; I need the architecture to disappear"? Help me make an argument for architectural character and specificity.

FE I think it's particularly complicated to think about that type of neutrality in an institution that holds so much symbolism and is already loaded with meaning. Should we become neutral at the end of that story? I don't think that's the right answer. Here we're talking about how we can see human culture through a different lens, and we need to be specific about it. We need to have a position.

34–35

Fig. 55 Frida Escobedo Studio, Boca de Agua hotel wood model, 2023. The structure is elevated to allow surrounding flora and fauna to flow beneath the hotel.

NADINE M. ORENSTEIN: We have a large collection of architectural drawings in our collection, but now, digital processes play such a significant role in architectural practice. So as a curator of drawings, I have to ask: What role does drawing play in your practice?

FRIDA ESCOBEDO: I still find that the fastest way to communicate is with pencil and paper (fig. 56). Basically all the ideas, all the annotations that I do with the team are on paper. It's collaborative work, and most of it is done on computers, with digital models (fig. 57). But I've found that for me, sketching is still the fastest way.

NMO Is drawing taught in architectural schools these days?

FE I think I have the tendency to draw by hand because I was part of the last generation at my bachelor's program that had drawing classes. We transitioned from drawing by hand to learning AutoCAD. Now the idea of sketching a quick detail in a notebook is lost, because people are very good at modeling them digitally. But often, in geographies where the definition of the project is not as detailed, and there's very little time or resources—like Mexico—you have to come up with solutions on the construction site. And the only way to communicate them is through a little sketch.

NMO When you start a commission, where do you start? Is it research? Is it putting down ideas quickly? For example, here—you've come to The Met. How do you even start?

FE I think a very important part of my work has become listening. So that's the first thing: really listening to what people think the problem is. And then realizing that that is not actually the problem; it's something else. Our work is actually problem-solving, and then adding a physical layer that transcends the problem, hopefully.

So I start by asking questions. In the case of The Met, what came from these discussions was the idea of weaving and creating different connections and different possibilities for seeing the collection. From there, we start organizing what we have, the material that we can work with, and then we see what's missing. And what's missing is what we're designing.

NMO How do you keep your vision intact? There are so many decisions influenced by the City, Central Park, the Trustees, and all of us at The Met.

FE It's difficult. On the one hand, there are the people outside the project, but there are also different perspectives internally. It's a collaborative effort inside the studio, too. Even that is challenging—making sure an idea doesn't become diluted or become something else. But I think the solution is just pushing it forward and testing it. And stepping back to see if the original questions are still there. If they're not, then you need to recalibrate the whole thing.

NMO I'm interested in this marriage of very practical questions and artistic questions. Our first meeting—when we really started the concept—wasn't about how the facade should look. It was about where the bathrooms and the elevators

Fig. 56 Frida Escobedo Studio, Serpentine Pavilion (sketch), 2018
Fig. 57 Frida Escobedo Studio, *Civic Stage* (digital drawing), 2013

should go. And it seems to me that you're juggling these different practical and artistic visions. There must be an effort to keep to the topic of what it will look like in the end.

FE But in the end, the experience is something that integrates all of these things, no? Where are the bathrooms, and where is the AC coming from—if these two questions are not resolved, then the central experience will not happen. It may seem like these very trivial, pragmatic things are not part of the experience. But they actually are. You are able to enjoy a moment because all these things were taken care of.

NMO One of the things that you showed us when you first presented your idea was this wonderful wooden model of the whole building that absolutely everyone in the meeting wanted for their desk (figs. 58, 59). It reminds us how big and complicated this place is. How do you keep the relationship of the Tang Wing to all the other parts of The Met in mind?

FE I can't remember who said this, but I think it was very precise: It's a condensed campus. It's a series of buildings that have been compacted into a single block. And you don't have that space between the buildings, which would be the streets or the plazas, but instead you have these different thresholds. I think the same thing happens inside a museum wing, no? The transition between gallery spaces is part of that sequence. And if you think about a single gallery itself, it's the same. You jump from seeing one artwork to the other, and the spacing between, what you experience between works, is as important as what you're experiencing between galleries.

 We've been talking internally about this concept of the space between things. If there's no space between things, they're one indistinguishable thing.

NMO I think one problem at The Met is that we like to fill up those spaces.

 I want to ask you—here you are, a woman in a male-dominated field, and here you are, working on the Tang Wing, a building at The Met, which has basically been built by men since the nineteenth century. I'm wondering how you've navigated this road, and how you feel about your position in this field.

FE Well, I feel like I have been very lucky, because things are changing. And I recognize all the work that has been done before me so I could be here. I just need to take that responsibility and pass it to the coming generations. But it has also been wonderful to see how, on many occasions at The Met, I've been sitting at a table with only women. And it's more about listening and talking

and seeing what we can do together, rather than competing and creating something that is like an absolute truth that needs to be followed. It's a little bit more fluid.

 I love that this is happening, not just with this work at the Tang Wing, but also in architectural schools, and in other projects that we're doing. People are starting to see that if we have that type of fluid conversation, then the necessary things—the really fundamental ones—start emerging. It's almost like the things that you don't need settle, and the things that are important start floating.

 Another way that my experience differs from the previous ways in which the Museum has been built is that my studio set up our offices inside it for a year. Being able to talk to you all and experience it from within has been really fundamental.

NMO I can see how that would be true. The day-to-day experience—for example, knowing how we get around and experience the building—would, I think, influence a lot.

FE And it's not just how the staff, as users of the Museum, are experiencing it, but also how you're transforming it constantly. We see it in real time. How a permanent exhibition can be affected or informed by the temporary exhibitions—the process of transformation, and how the reading completely changes just by moving one piece. I think that has been wonderful to see.

Figs. 58, 59 Frida Escobedo Studio, wood model of The Metropolitan Museum of Art, 2022

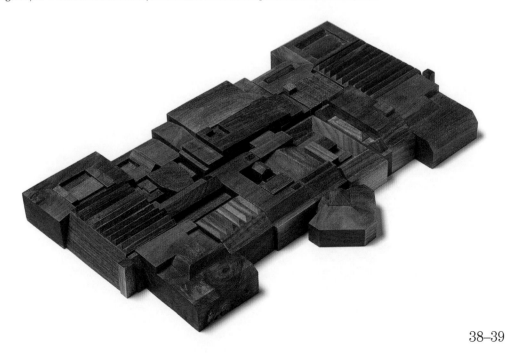

JEFF L. ROSENHEIM: At some point or another, you mentioned that you have a photograph made by your sister in your home, an aerial view of a meandering river cutting through mountains (fig. 60). Might you tell me about that?

FRIDA ESCOBEDO: I have two sisters. The older one is a photographer, and the youngest is a poet. There are no other artists or designers in the family, so the three of us were a surprise for everyone. I think photography offered my sister the ability to grasp at a moment in time.

JLR Yes. Photography holds time.

FE That's right, photography holds and liberates time, and I think it's the same for the river. It's the same river, but it's different water. So the photo kind of condenses all of these things that I like about photography. It was taken from an airplane, and she had to be very aware of what was happening to grasp that distant, serendipitous moment.

JLR When I was raising my kids, I tried to explain to them that every street corner is a little bit of a theater. Even if there are no people there, it's a performance of light. I think that what you have brought to the field of architecture and design is a deep appreciation of how that performance works. And I think the best architects are storytellers. You use materials, textures, forms, and light to create meaning that is abstract, like that silver thread of a river, and that is also historical and personal.

FE More than creating meaning, I think it's transforming meaning. All the symbolism, all these different narratives are out there. It's just a project of rearranging them, or translating them, or weaving them into something new—something that becomes deeply personal, but that, hopefully, will connect to somebody else.

Fig. 60 Ana Gómez de León (Mexican, born 1991), *Paths*, 2013. Inkjet print, 15⅝ x 15 in. (39.6 x 38 cm). Private collection

JLR That's a beautiful thing. One thing that's in your architect's toolbox is light. I'm wondering how light, transparency, and opacity will play a role in the solutions you're seeking for the Tang Wing.

FE The challenge is that most of the spaces need to be protected from light, so the experiences that are in touch with natural light have to be very thoughtfully designed, and most of them have to do with the moments of pause. We're thinking about the experience of transitioning out of being very immersed in this interior world. We don't want to push people out of that experience immediately. We want to allow people to emerge softly. You can go back to your body, to your surroundings, and to your reality before you go back to the busy streets of New York.

JLR I'm really interested in your use of stone, and the repetitive use of stones of the same size. I wonder whether you can talk a little bit about that material language that you've developed on so many different projects.

FE Well, in general, the intention is to use material that can tell the story of its own production. I think stone tells a story of locality, where it comes from, what the industrial processes are that make it the way it is right now. Then, I've found that repetition creates something to react to, something that moves away from neutrality. It's not a blank wall. It creates a sort of rhythm that brings your attention to it.

JLR I think it was Mies van der Rohe who said that architecture starts when you carefully put two bricks together. You don't necessarily have architecture when you only have one brick. But, when you have two bricks, and they're intentionally put together, then you've created something.

FE And that implies that someone needs to put that brick next to another brick. When you have these monumental pieces of art or architecture, sometimes you forget the labor that needed to happen behind the scenes. So, this idea of a module has also to do with labor, and with scale, and with effort. That's why I like the Héctor Zamora piece that was done for The Met roof commission in 2020 (fig. 61).

JLR Me too. What is the role of photography in your creative process? Do you look at your buildings through the camera?

FE I don't use photography to see the completed object. I think there's this feeling after you finish a building—and I don't believe they're ever finished—that you have to do this set of photographs to really show the perfect state of that piece of architecture. It's almost necessary, but I feel like it's so limiting. For example, when we were doing the Serpentine Pavilion, a couple of photographers asked us, "What's the perfect shot?" And the response was just: There is no one moment. You just need to go in and see how you connect with the space.

JLR You once designed a house for a photographer, the Casa Negra. Will you share a little about that project's origins and what you did with that commission?

FE I believe that was truly my first project. I did it with Alejandro Alarcón, who was my partner at the time. The commission was from a friend of ours, who was young and had very little money, but had received this piece of land on the periphery of Mexico City. He gave us a lot of freedom, which we used to make as much space as possible with very few resources. We made this single room that was double height, so he could have this little mezzanine level and his bed and a small bathroom. You entered from a bridge that we made across this V-shaped branching tree (fig. 62). There's a little moment of compression when you cross that threshold. And then the view expands into this double-height space, which was particularly dramatic in the evening, because you could see the city.

JLR It's a black box, which is the core idea of a camera—it's a room with a view. And I know that's also some of the language you use to talk about the project at The Met. In your vision, how will that view—that room, or entire building, with a view—help us see and understand both the city and modern and contemporary art?

FE The current wing is not looking at the Museum. So, the first exercise is to allow it to look back at where it is coming from, and then the second is to connect to what's outside. We're still working on how we want to create those openings and how we want to build that connection. It needs to be a very delicate balance between how you're framing the views and what you're showing in the gallery spaces.

JLR Right. It both has to look out and look back. You talk about that beautifully, Frida—about the fact that, by the time people get to the Museum's southwest corner, they have walked through and experienced centuries, millennia of culture. When they get to this new space, we're hoping that they will think about that journey and think about our time.

FE That's correct. The intention is for it to be creating, in some moments, continuity, and in other moments, reflection. Looking back and seeing all these different layers that have been formed at different moments in time. And then, hopefully, emerging to see where we're standing now.

Fig. 61 Héctor Zamora (Mexican, born 1974), *Lattice Detour*, 2020. Terracotta bricks, mortar, and steel, 11 x 101 ft. (3.4 x 30.8 m)

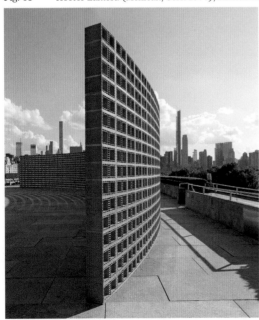

Fig. 62 Frida Escobedo and Alejandro Alarcón (Mexican, born 1975), Casa Negra (conceptual collage), 2004

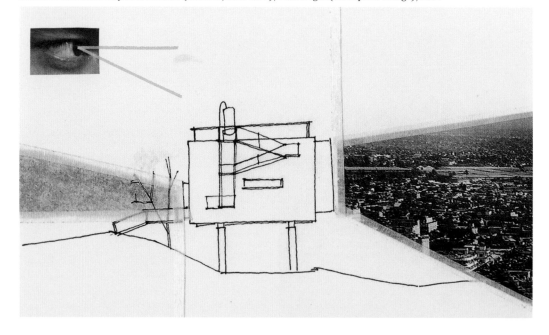

DAVID BRESLIN: In your work, I see a commitment to a certain modernist trajectory—and yet, you also don't take those historically modernist values of transparency, clarity, and order as givens.

How do you characterize your relationship to history? How do you diverge from it, disagree with it, or want to go into a different direction with your work?

FRIDA ESCOBEDO: My understanding of architecture is multilayered because of where I grew up. In Mexico, we have a complicated relationship with modernism. It might come from that history of translating that which was imposed on us: a city imposed on a lake, or the colonialist city imposed on the Aztec city (figs. 63, 64).

We borrowed modernism from the US and Europe and translated it into something that was peculiar and unique to us. Where in other places it was about neutrality and mass production, in our case, it became an expressive tool.

I think that informs my thinking. Like, what are the things that are inscribed into the architectural tradition? And how, in many other geographies, have they been translated and turned into something else?

DB I like this idea of translation because, I think, translation always has to do with who you think your audience is going to be.

FE Yes. And in some architectural jobs, there's a specific plan and audience. You're speaking to the person who is going to be the one using the space. But in the case of public spaces, it's very difficult. It's like writing a letter to someone you don't know.

The first time that I encountered this was with the pavilion for El Eco (fig. 65; see pages 54–57). It was a project of engaging with an audience that I didn't know. And that's why it became so important to try to register the life and activities that happened within that pavilion, and to see how people imprinted their own use of space within it.

The main challenge is just to understand that when you have a reading of a space, it's *today*. But you don't know what's going to happen in the near future. It's always a projection. That's why I think that architecture is always unfinished—

because even when it's completed, it's a relic of the time. It becomes a ruin of that original idea.

DB It's such a beautiful idea: incomplete architecture. We might think of architecture as the most finished, the most complete art form. But for so many artists, particularly modernist and contemporary artists, the work isn't finished until the viewer interacts with it.

I wonder where the art has figured into your thinking about making this wing. When you're designing spaces for art, what are the considerations that you keep in mind? Can you share a little bit about La Tallera, the Siqueiros studio and museum? Is there anything from that experience that informs how you're approaching the Tang Wing?

FE It's challenging to compare them because La Tallera was a space of production, the place where Siqueiros was living and projecting, quite literally, his work into the public space (see pages 58–61). That's why using his murals for the building facade became such a natural gesture. It was a

Figs. 63, 64 Remnants of the Aztec Templo Mayor in central Mexico City

42–43

single discourse that culminated in that moment of: *art needs to be public and it needs to be accessible for everyone*.

The Met wing will have this other purpose: holding all of human culture through many different perspectives. It's a bigger challenge because, of course, it's not only pieces from the permanent collection. Those pieces will create some anchor moments. But at the same time, all these other things will be shifting around them. So that's when the design starts becoming a little bit more porous, or permeable. There's a sense of permanence, but the unfinished part is the stories surrounding those elements, which can be infinite.

DB So many conversations, particularly about museum architecture, have circled around these ideas of flexibility versus permanence. And I think it's interesting to see, in your work, that you somehow manage to get the best of both worlds. There is openness, but there is also a kind of directionality.

Where does that come from? Are there architects who have informed your way of having both to create something new?

FE One interesting example is a museum in India by Le Corbusier that has a similar scheme to a pinwheel, where the circulation almost becomes the motive of the narrative. But it's not prescribing what the pathway should be. I'm interested in more open-ended circulations like this.

And I think that's also very like Barragán. Particularly his residential projects, where there are so many shifts of scale. You can go from a compressed space to an open garden to something that feels like a room but is actually a terrace, and then back again into more monastic

Fig. 65 Frida Escobedo Studio, Museo Experimental el Eco Pavilion, Mexico City, 2010

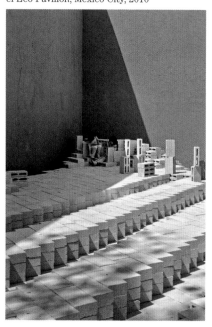

spaces that are, in turn, connected to more open ones (fig. 66).

This kind of fluidity, I think, becomes very relevant in a contemporary museum, because you're trying to establish moments where there's specificity, but then other moments where there's connection.

DB I know a metaphor that you use frequently is that of weaving. Which is, again, a very beautiful way of thinking—where these materials that we think about as soft and malleable come to create something of endurance. I wonder how weaving has entered into your architectural vocabulary, and why you find it so meaningful for framing your ideas.

FE It became particularly relevant for The Met because we are pulling threads of history and thinking about what the continuities should be, and about how to create different textures or landscapes that allow those threads to be read in different manners as you move through the space.

The fabric becomes richer the more threads that you have—if you have a double weave or a triple weave—and you have more possibilities of expressing that texture, or that exchange: how it can transform and emerge, or how it can be a bit more hidden and become the foundation that something else emerges from.

DB You and I have talked before about Le Corbusier; we've talked about Renzo Piano; we've talked a bit about Lina Bo Bardi, and about Luis Barragán. All very interesting references that have very specific relationships to materiality. When you think of Barragán, you will always think of color. When you think of Piano, you inevitably think of louver light. When you think of Le Corbusier, you think of the distinct role of furniture in his practice.

You've done work in all these arenas—furniture, design. How does keeping in touch with those forms influence what edifice, structure, and proportion mean to you?

FE I think it's all related. The way that you place an object—whether it's a chair or the difference between two walls—it's all about what that object does to space and how that changes interactions between people.

There's this beautiful term in Japanese, *ma*. The space between things. And I think that that's the main goal, no? To design that space between things. It could be anything. Designing fabric, designing furniture, designing lighting—it will all affect the way that you're receiving that in-between space, that void, that suspended moment that you keep in your memory. I think it's the suspended moment that is the main goal—that's the design proposition. It's not the building itself, it's the suspended moment.

Fig. 66 Luis Barragán (Mexican, 1902–1988), Casa Gálvez, Mexico City, 1955

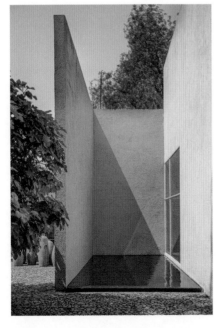

WORKS BY FRIDA ESCOBEDO

2004

* Casa Negra
Mexico City
 Collaboration with
 Alejandro Alarcón

2010

* Hotel Boca Chica
Acapulco, Mexico
 Collaboration with
 José Rojas

* Museo Experimental
el Eco Pavilion
Mexico City

2012

* La Tallera
Museum and former studio
of David Alfaro Siqueiros
Cuernavaca, Mexico

* *Split Subject / El Otro*
LIGA, Space for Architecture
Mexico City
 Exhibited at Guggenheim
 Museum Bilbao (2018),
 Museo Franz Mayer, Mexico
 City (2020), and Galerie
 Nordenhake, Mexico City
 (2020)

2013

* *Civic Stage*
Lisbon Architecture Triennial

2014

89plus Americas Marathon
exhibition design
Museo Jumex
Mexico City

Aesop Invisible Dog pop-up store
Brooklyn

Aesop Lincoln Road store
Miami

Aesop Wynwood store
Miami

Octavio Paz bookstore
Fondo de Cultura Económica
Mexico City

2015

* *Under the Same Sun: Art from
Latin America Today* exhibition
design
Museo Jumex / Guggenheim
UBS MAP Global Art Initiative
Mexico City

* *You Know You Cannot See Yourself
So Well as by Reflection*
Victoria and Albert
Museum pavilion
London

2016

Aesop Coconut Grove store
Miami

Aesop Oxford Exchange store
Tampa

Longing for Belonging
Oslo Architecture Triennale
 Collaboration with
 Guillermo Ruiz de Teresa

Marius de Zayas
exhibition design
Estancia FEMSA–Casa
Luis Barragán
Mexico City

Museo Jumex bookstore
Mexico City
 Collaboration with
 Esrawe Studio

* *A Very Short Space of Time
Through Very Short Times of Space*
Highland Hall courtyard screen
Stanford University Graduate
School of Business
Palo Alto

2017

Aesop West Loop store
Chicago

DADA Zúrich exhibition design
Estancia FEMSA–Casa
Luis Barragán
Mexico City

2017, continued

Estaciones (Estación #9)
Arthur Ross Gallery
New York

Estaciones (Estación #16)
Biennale d'Architecture
d'Orléans
Parc Floral de La Source
Orléans, France

If We Want to Continue
Neutra VDL House
Los Angeles

* Randolph Square
installation
Chicago Architecture
Biennial

2018

* Mar Tirreno residences
Mexico City

* Serpentine Pavilion
London

Shanghai Biennale
exhibition design
Power Station of Art

2019

Aesop Park Slope store
Brooklyn

Cleo Rogers Memorial Library
Plaza installation
Exhibit Columbus
Columbus, Indiana

*Ettore Sottsass and the Social
Factory* exhibition design
Institute of Contemporary
Art, Miami

* *From Territory
to Inhabitant*
INFONAVIT Housing
Laboratory prototype
Apan, Mexico

2020

* Niddo Café
Mexico City
 Collaboration with
 Mauricio Mesta Arquitectos

* *Lina Bo Bardi: Habitat*
exhibition design
Museo Jumex
Mexico City

2021

Pasha de Cartier
Laguna México
Mexico City

*Unseen: Anni Albers's
Tapestry Today*
MAXXI: Museo nazionale
delle arti del XXI secolo
Rome

2022

Casa Gruener
Mexico City
 Collaboration with
 Mauricio Mesta Arquitectos

2023

* Boca de Agua hotel
Bacalar, Quintana Roo,
Mexico

* *Cartier Design: A Living Legacy*
exhibition design
Museo Jumex
Mexico City

* Galerie Nordenhake
Mexico City
 Collaboration with
 Mauricio Mesta Arquitectos

In progress, 2025

* 30 Otis Street plaza
San Francisco

* 311 Bergen Street
residences
Brooklyn

* Avenida Juárez hotel
Puebla, Mexico

Casa LM
San Miguel de Allende,
Mexico

Casa Monte Líbano
Mexico City

* Ray Harlem multiuse
building and National
Black Theatre
New York
 Collaboration with
 Handel Architects

* Yola Mezcal distillery
Oaxaca, Mexico

* Oscar L. Tang and H.M.
Agnes Hsu-Tang Wing
The Metropolitan
Museum of Art
New York

Unbuilt

Villa 49
Ordos 100
Ordos, China
 Invited proposal,
 2008

Regional single-family
residence
INFONAVIT
Saltillo, Mexico
 Invited proposal,
 2014

Displacement
MoMA PS1
Young Architects Program
New York
 Competition finalist,
 2016

Urban redensification
INFONAVIT
San Juan del Río, Mexico
 Invited proposal,
 2017

Collins Park
Miami
 Competition winner,
 2018

* Illustrated in this section

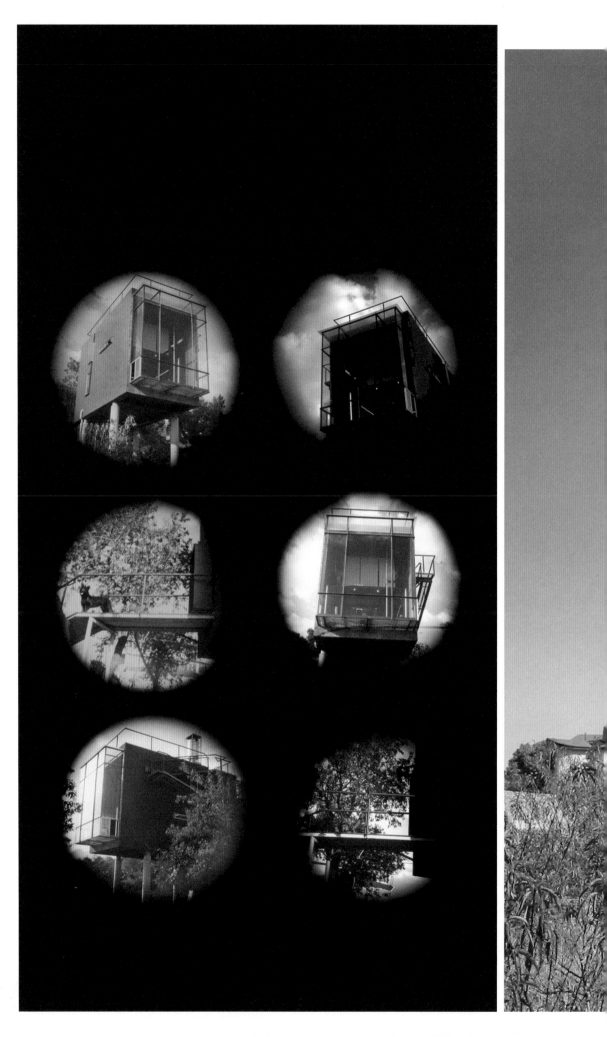

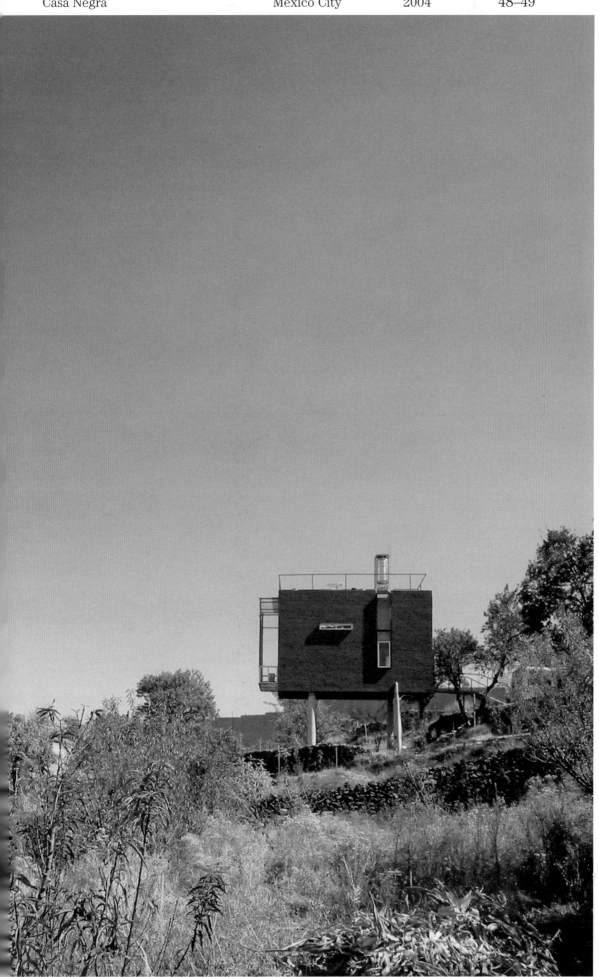

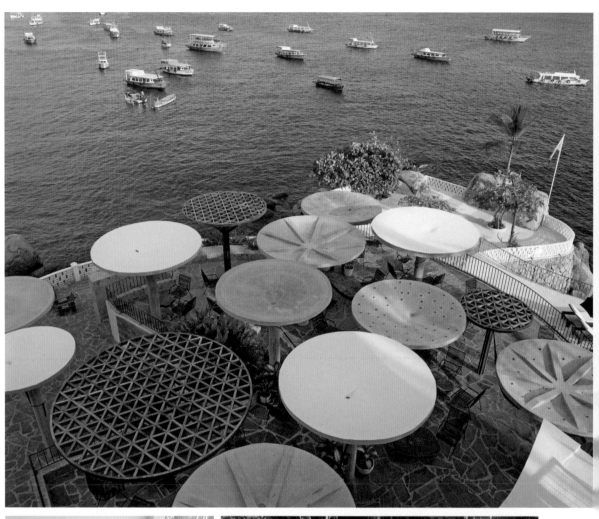

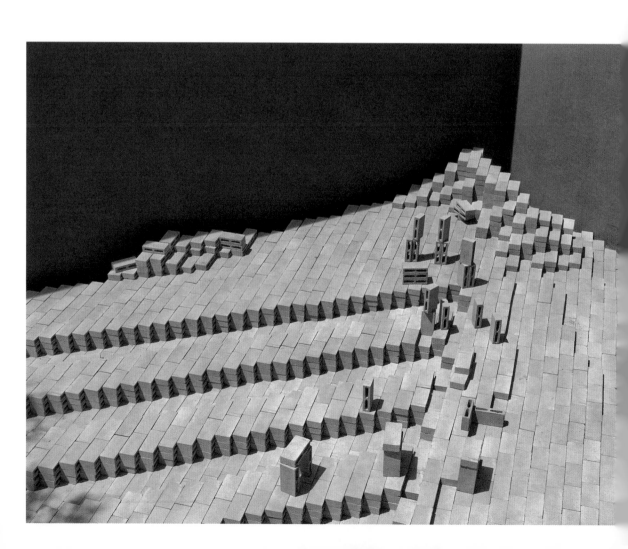

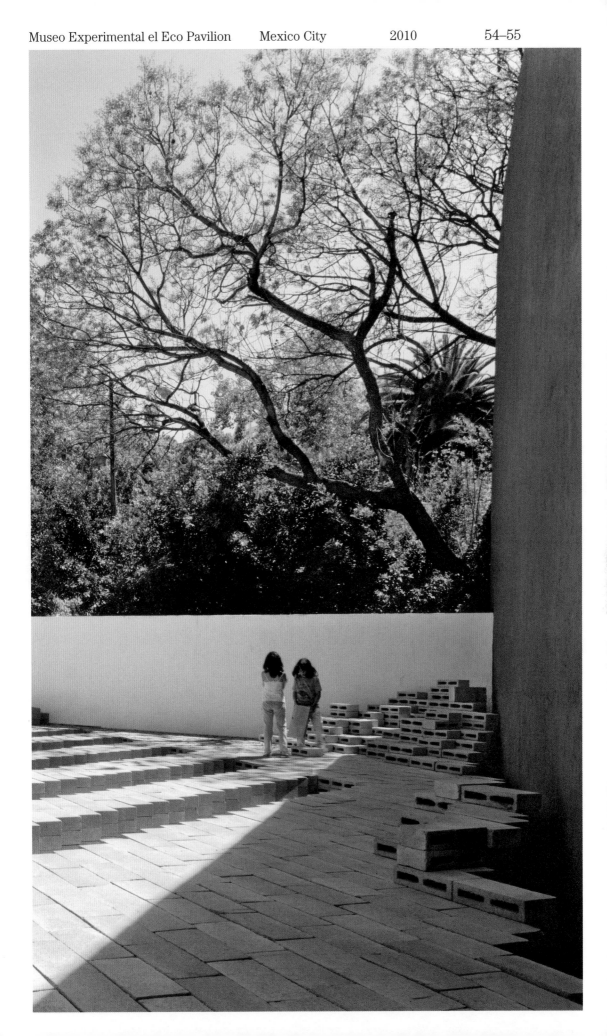

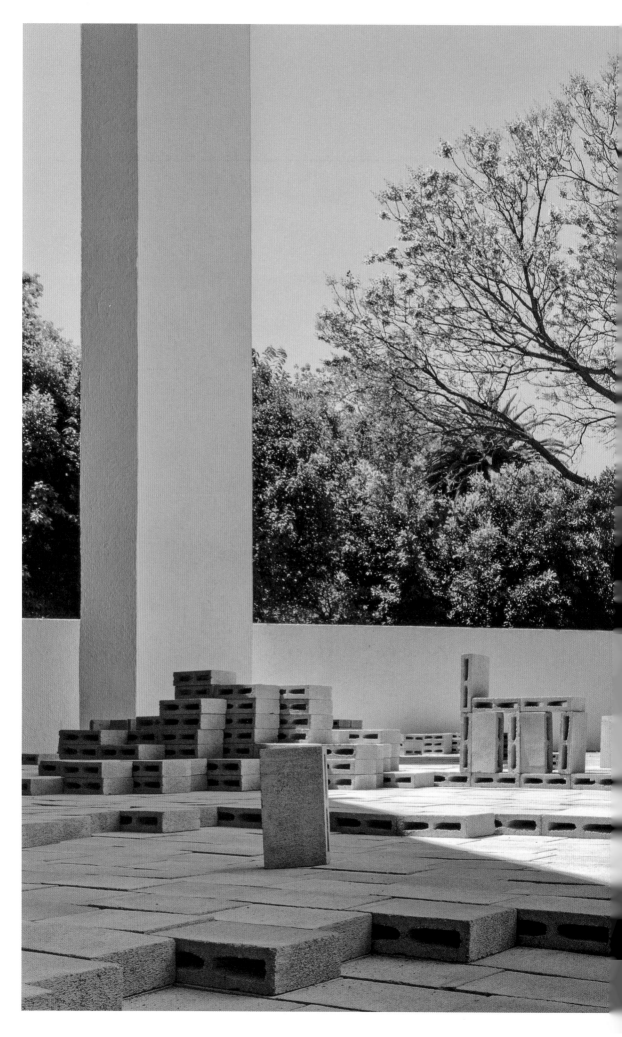

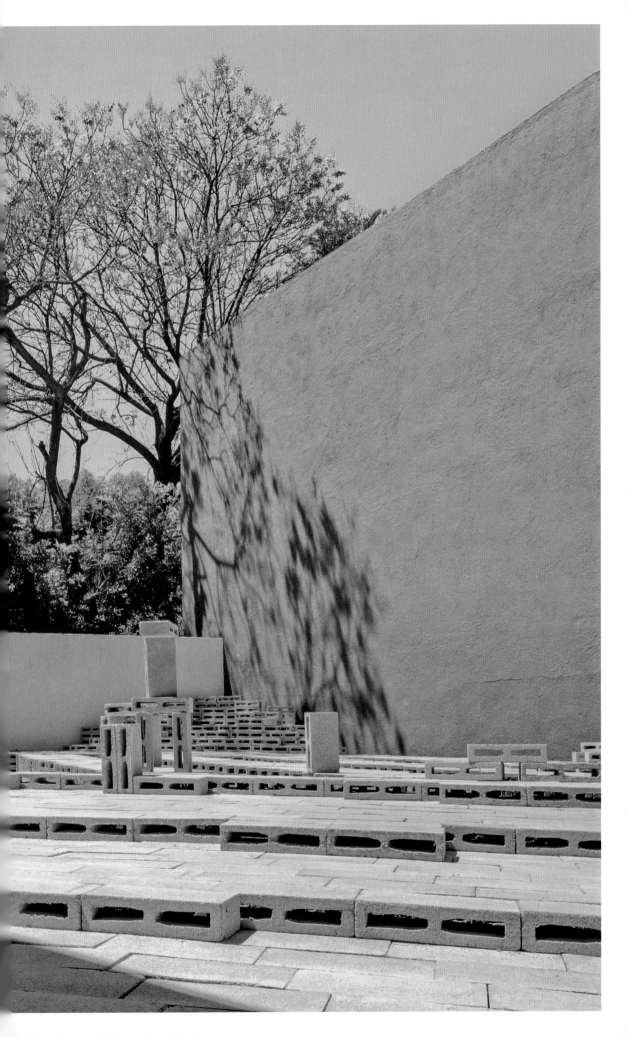

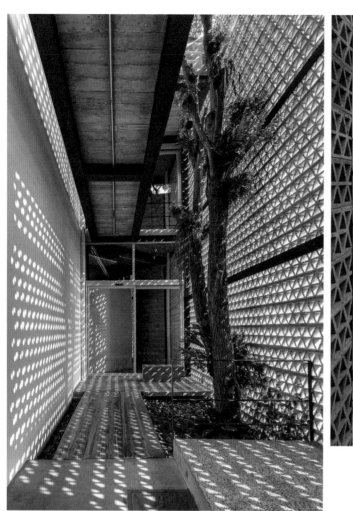

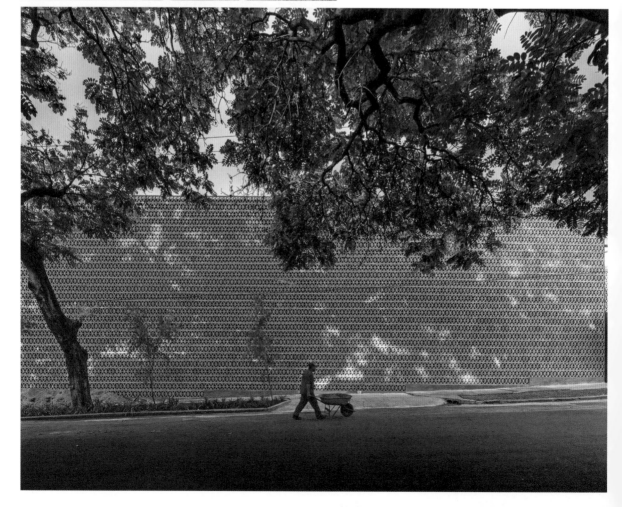

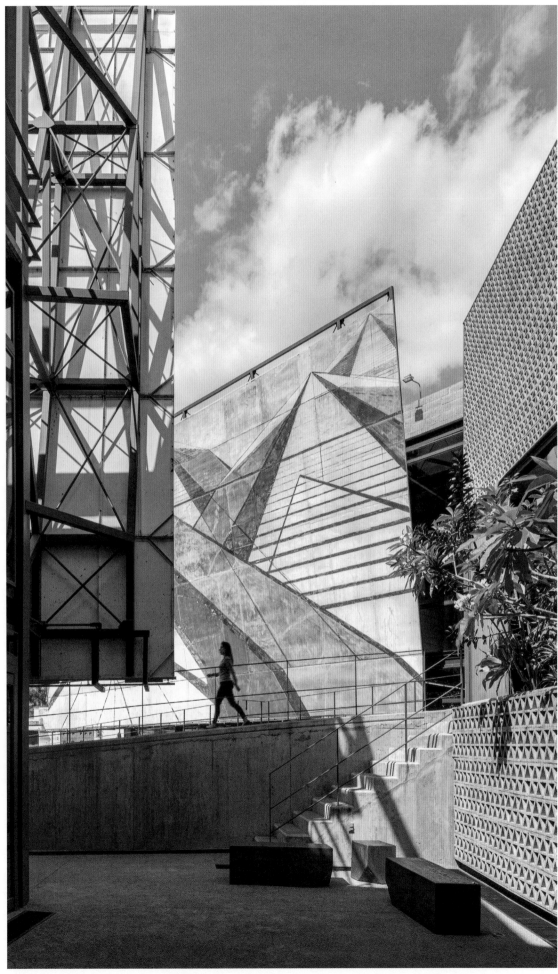

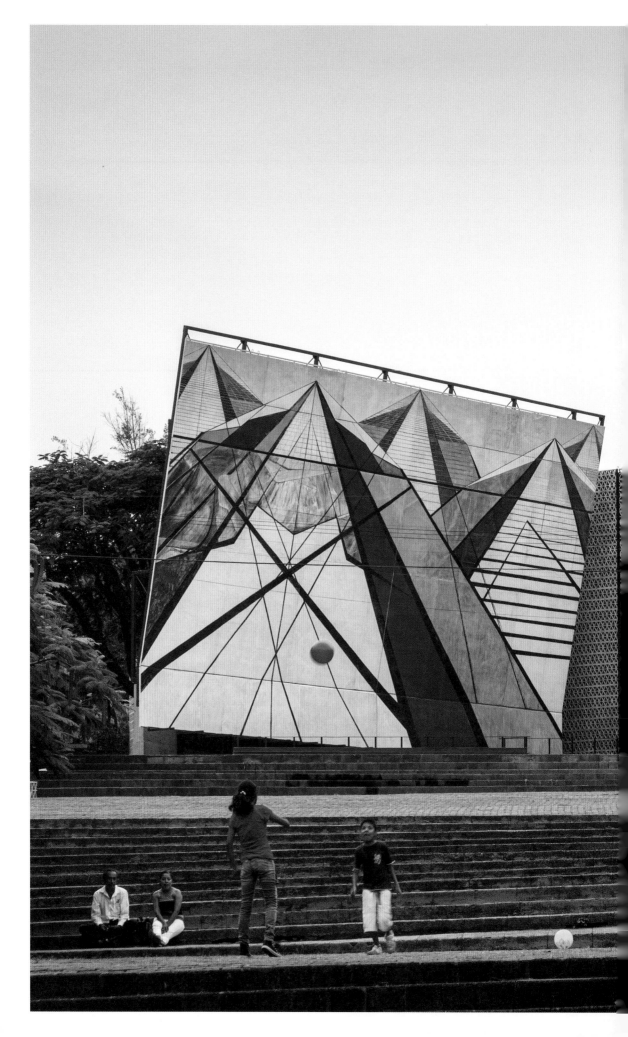

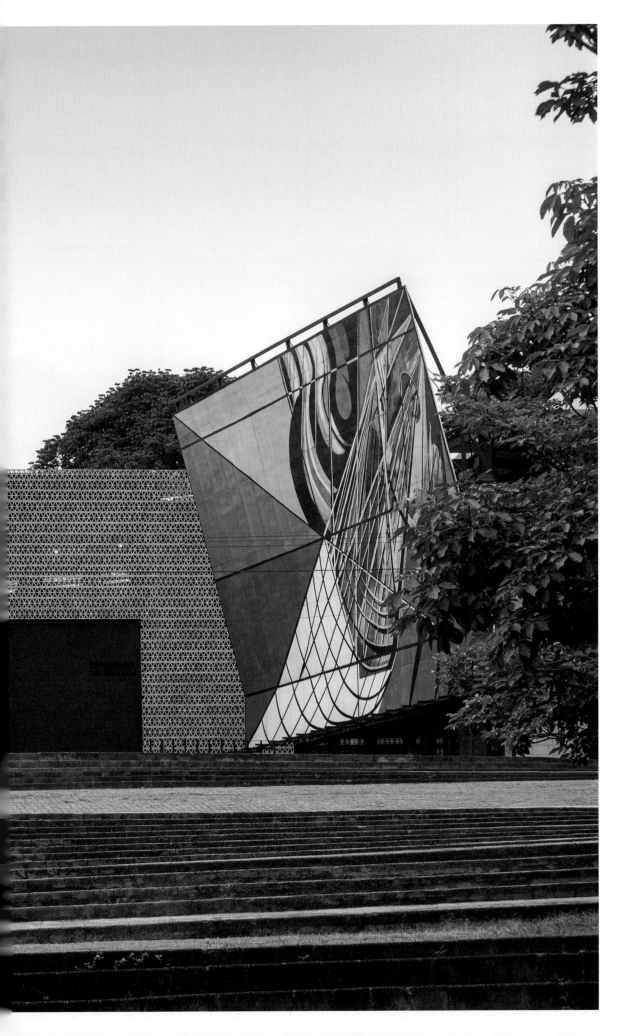

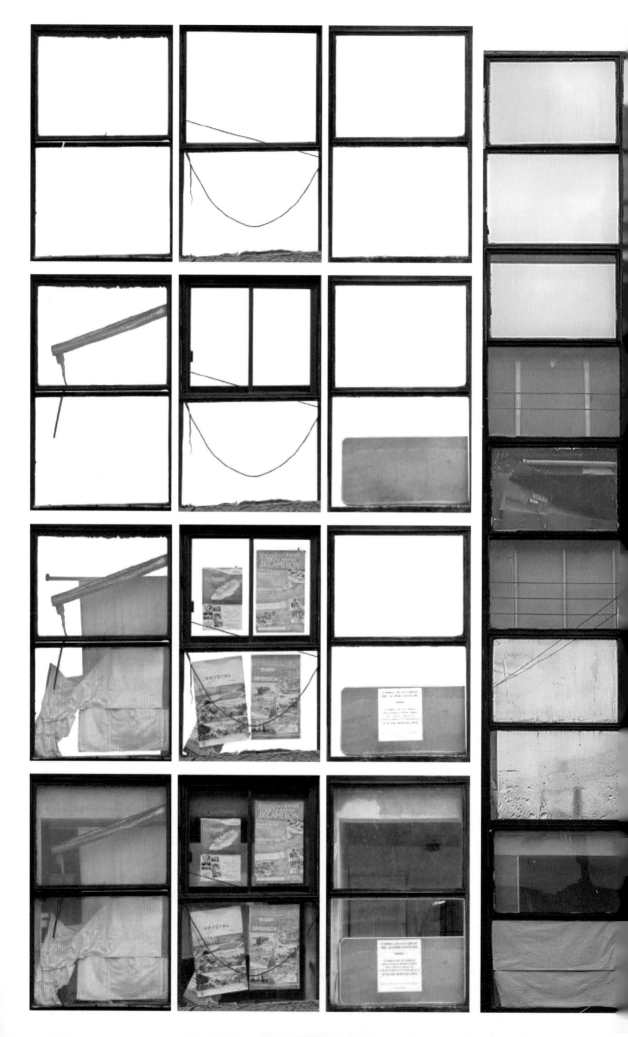

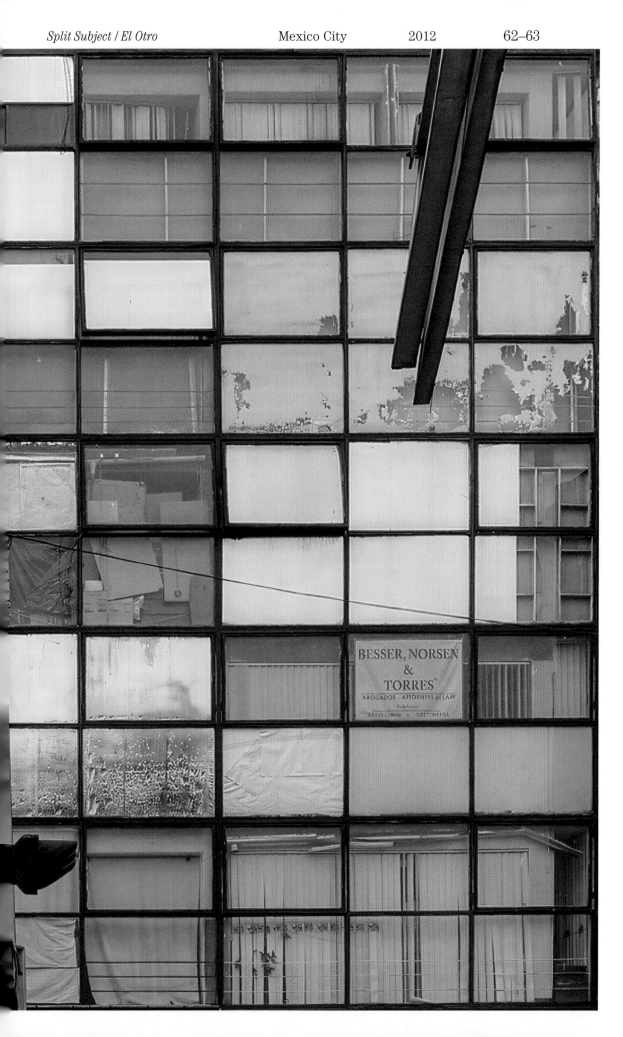

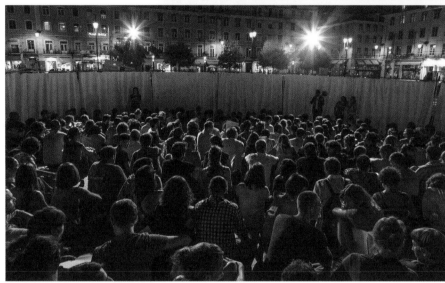

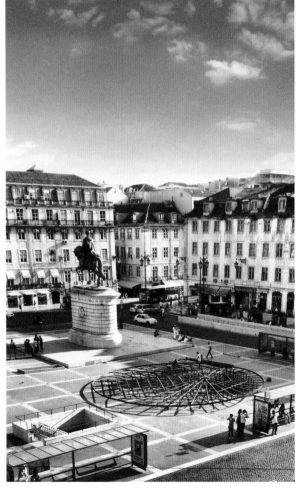

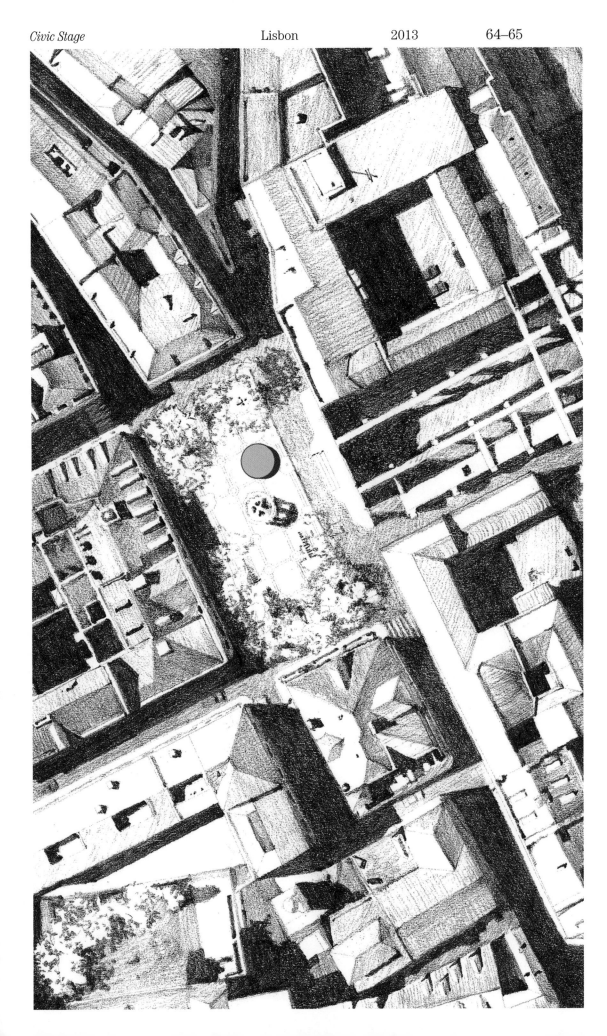

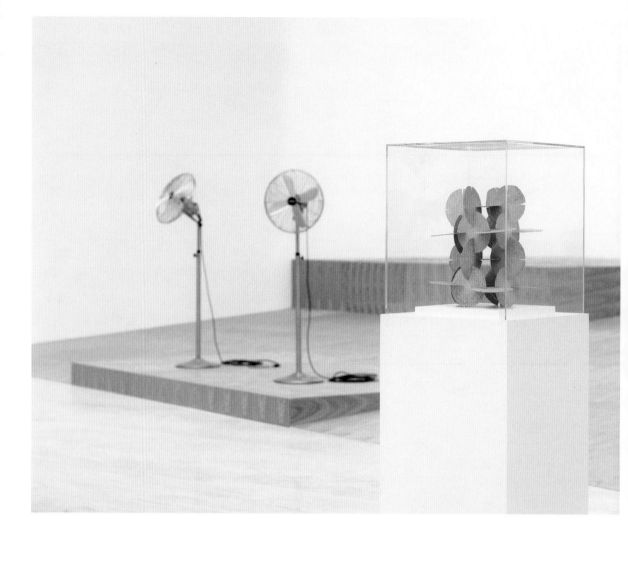

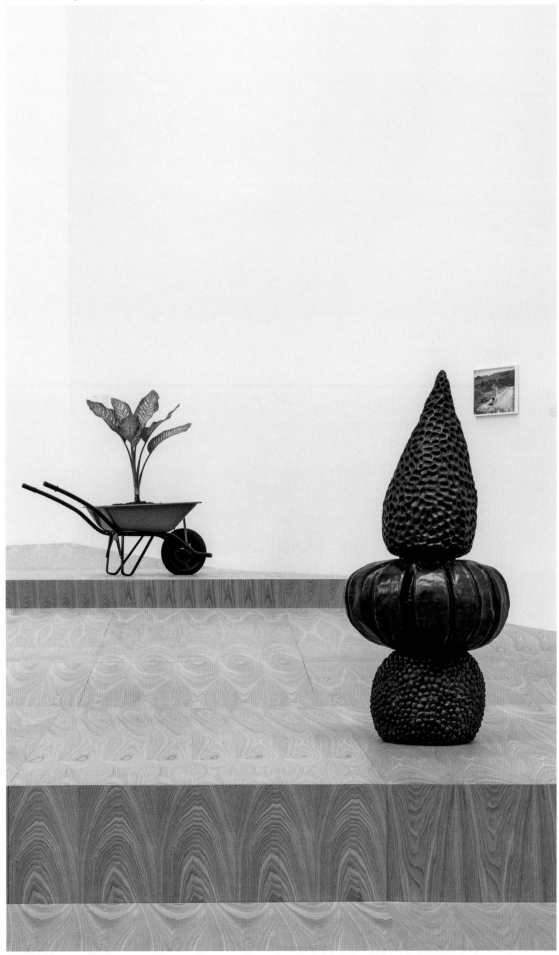

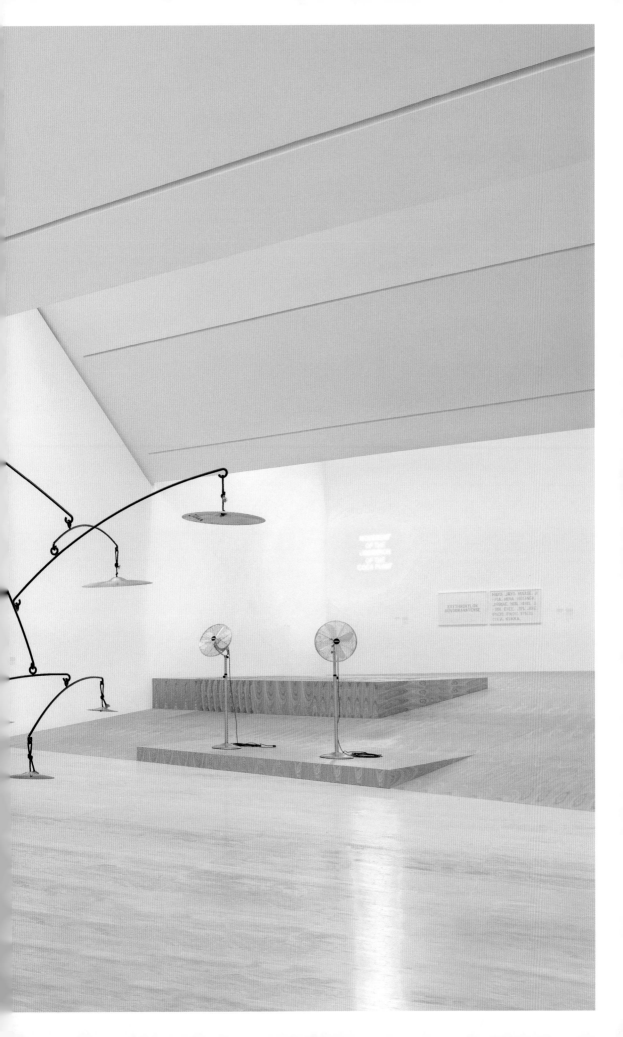

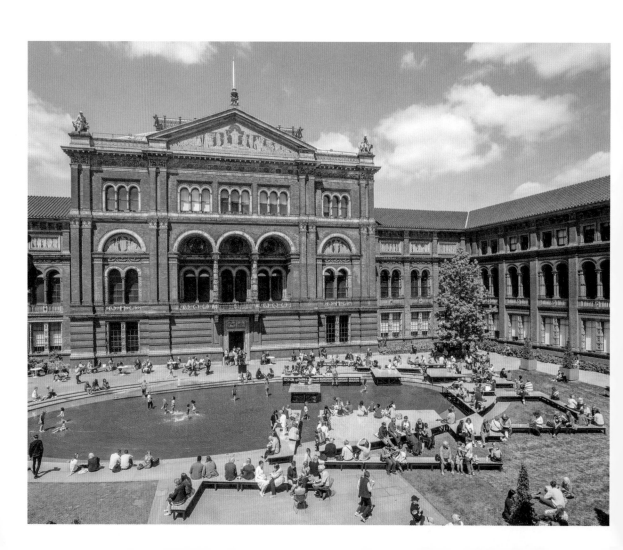

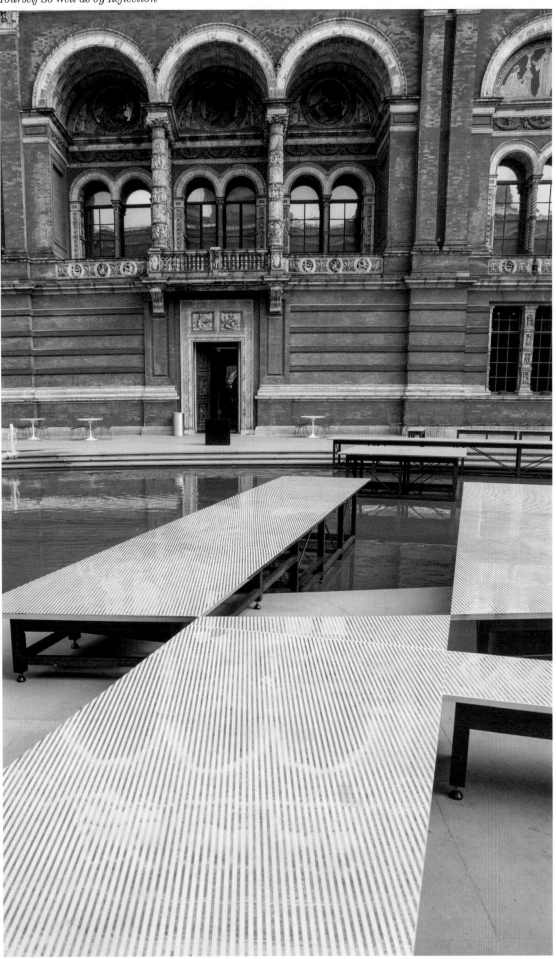

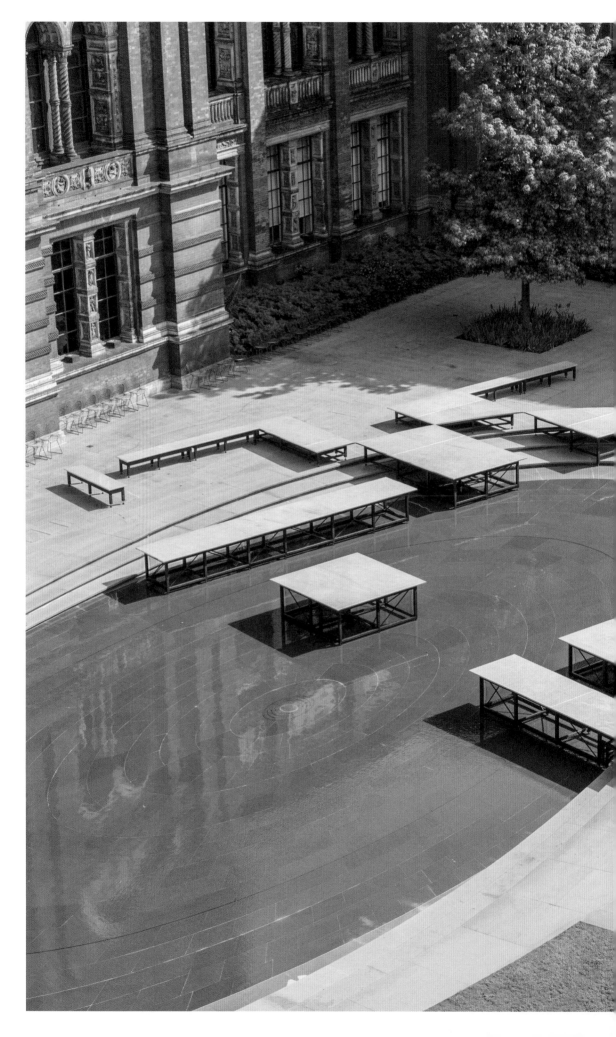

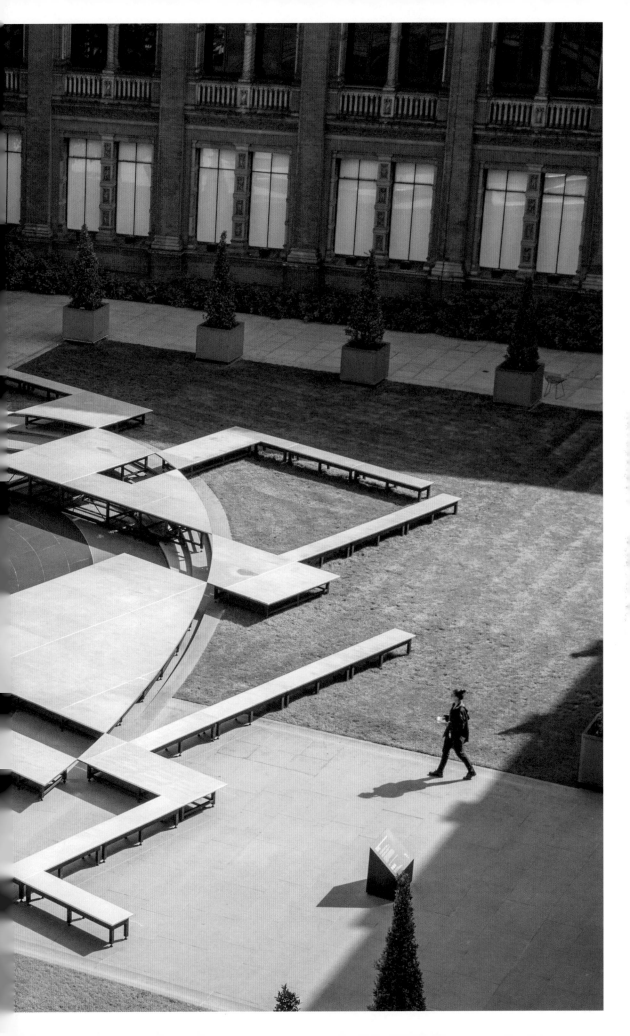

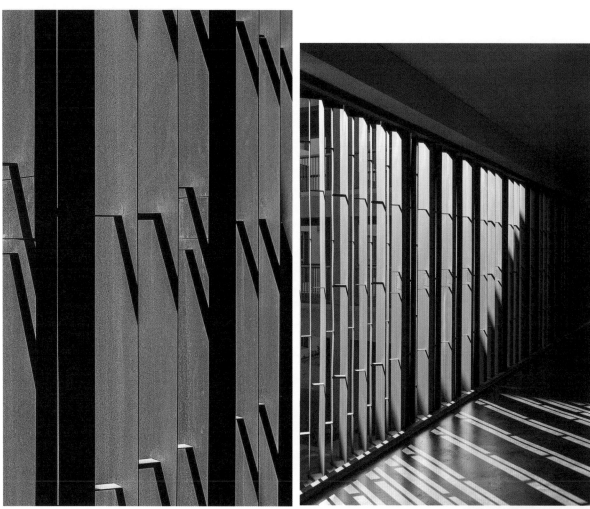

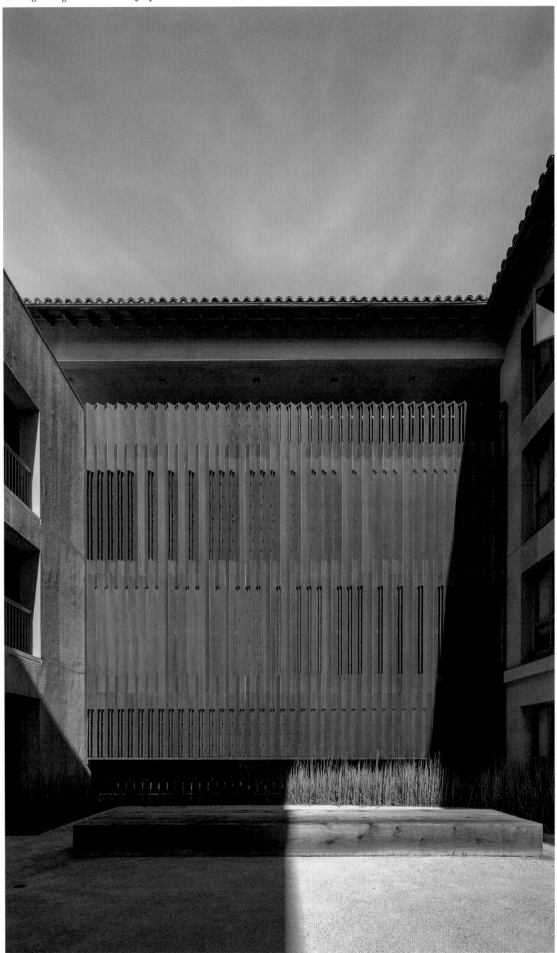

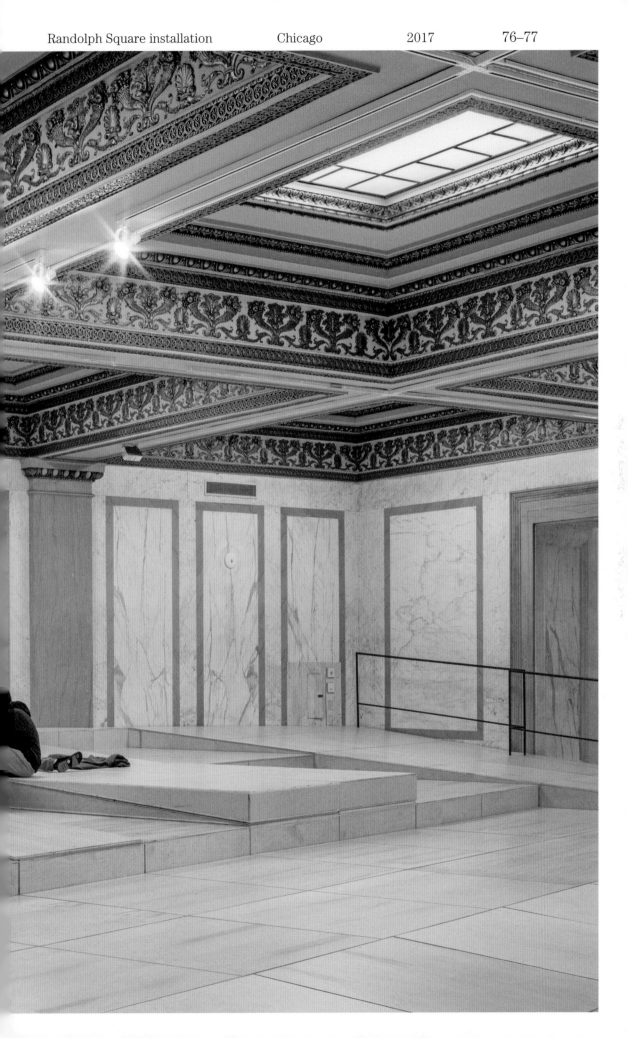

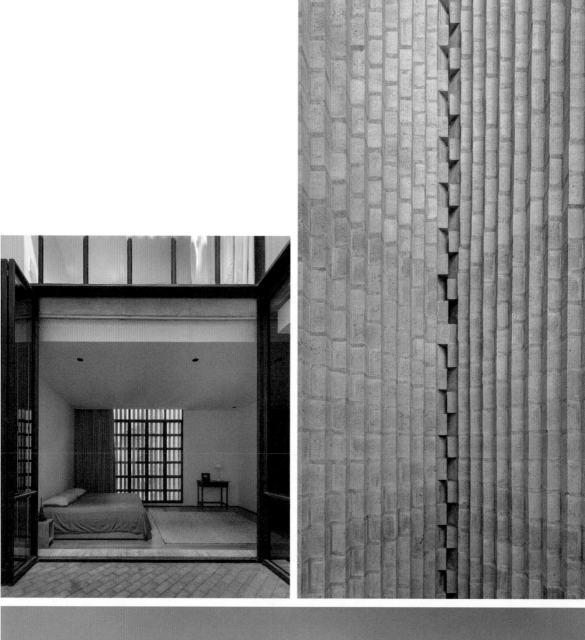
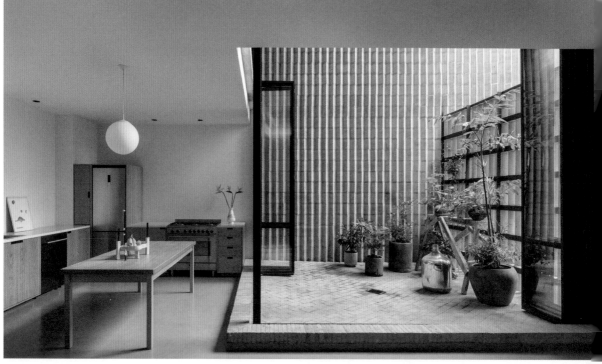

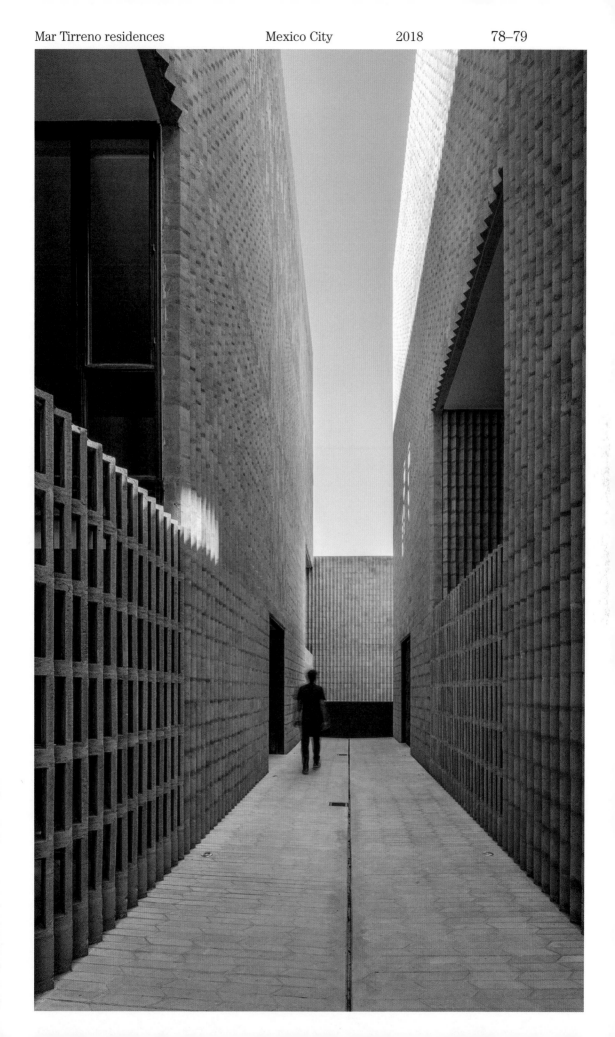

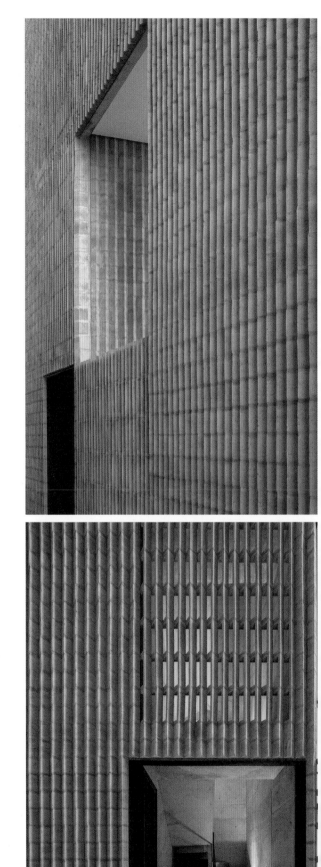

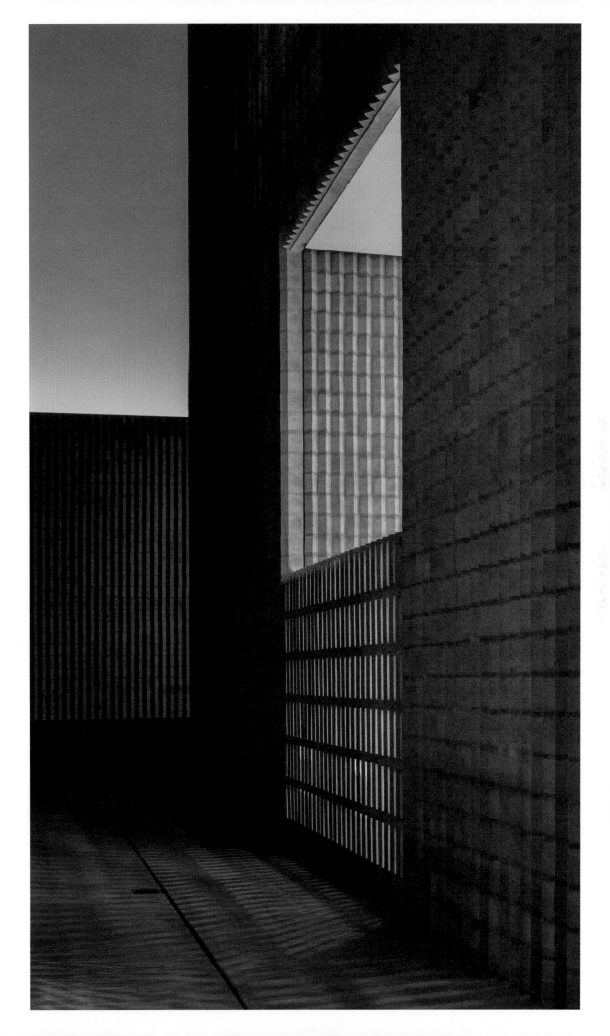

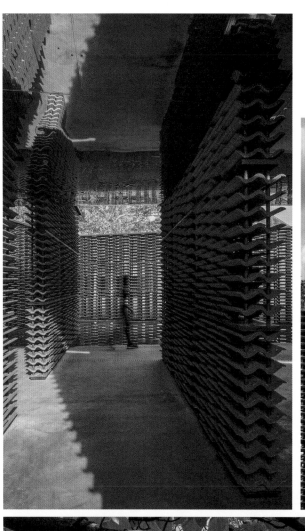
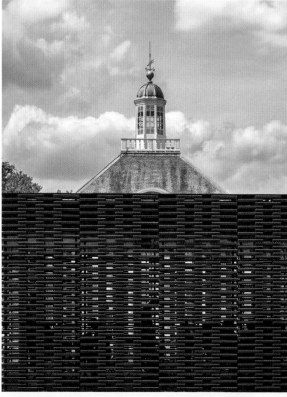
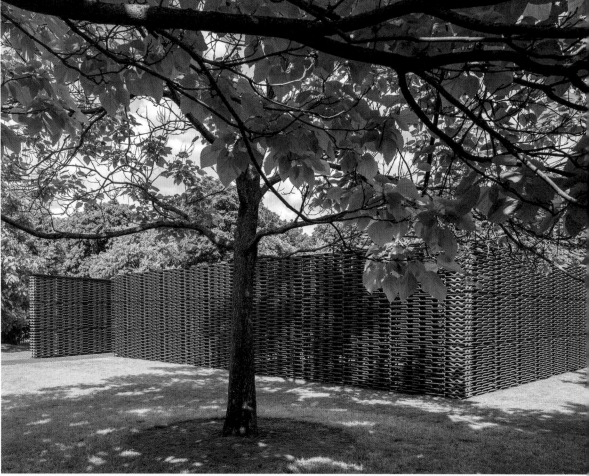

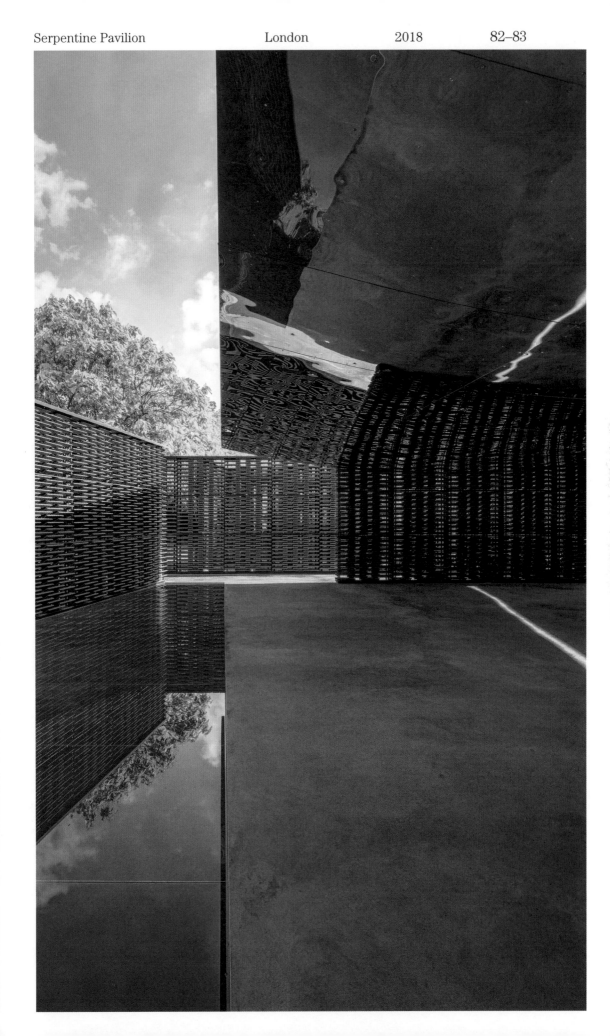

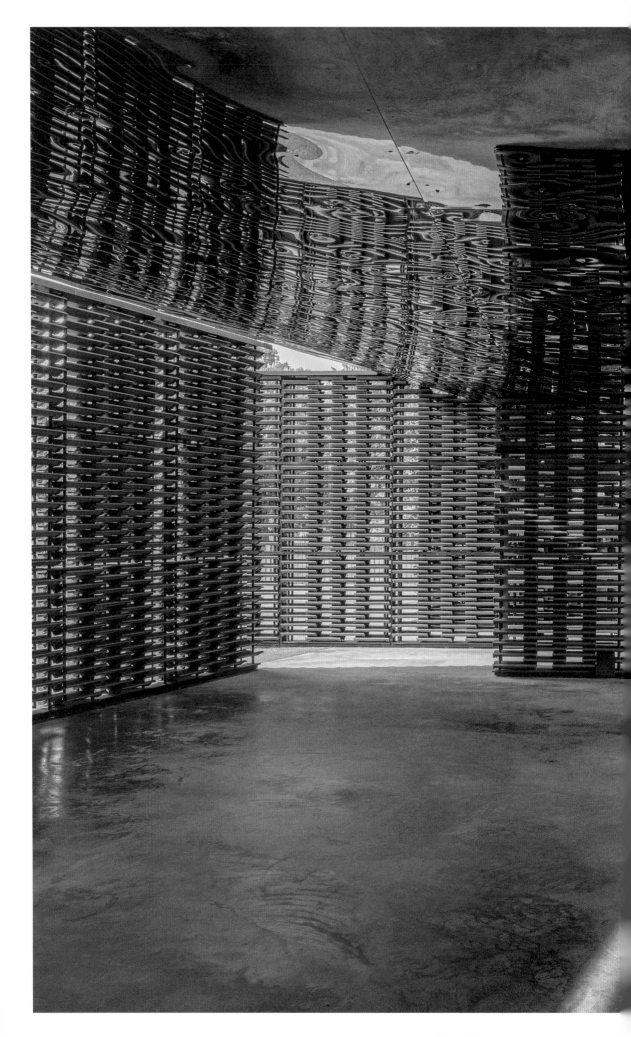

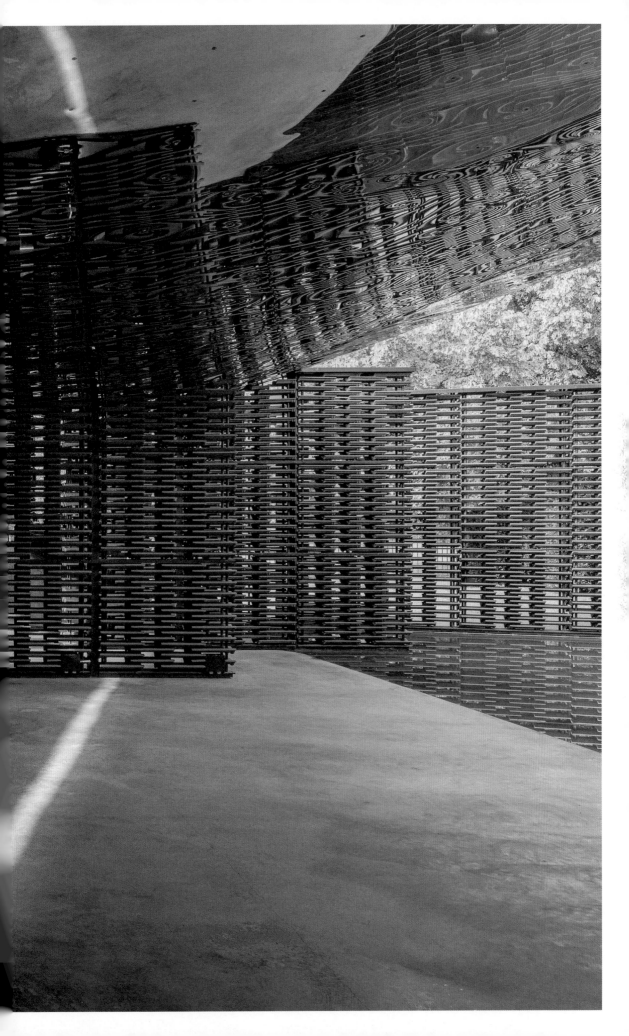

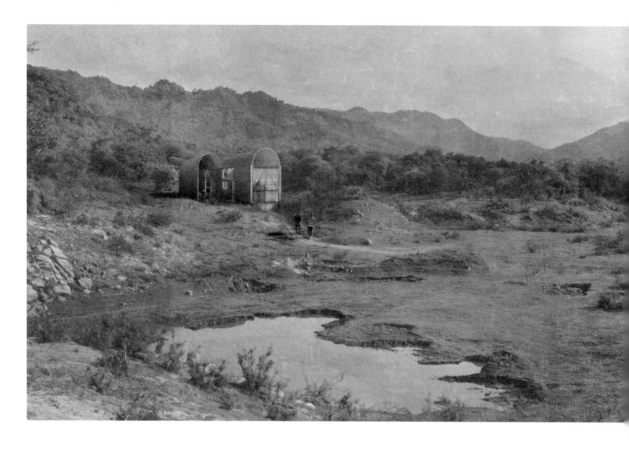

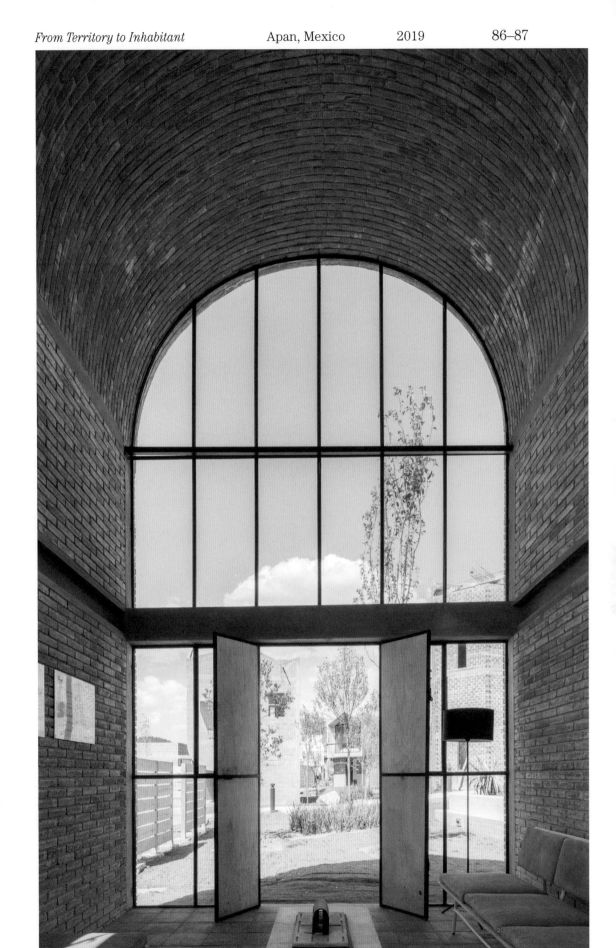

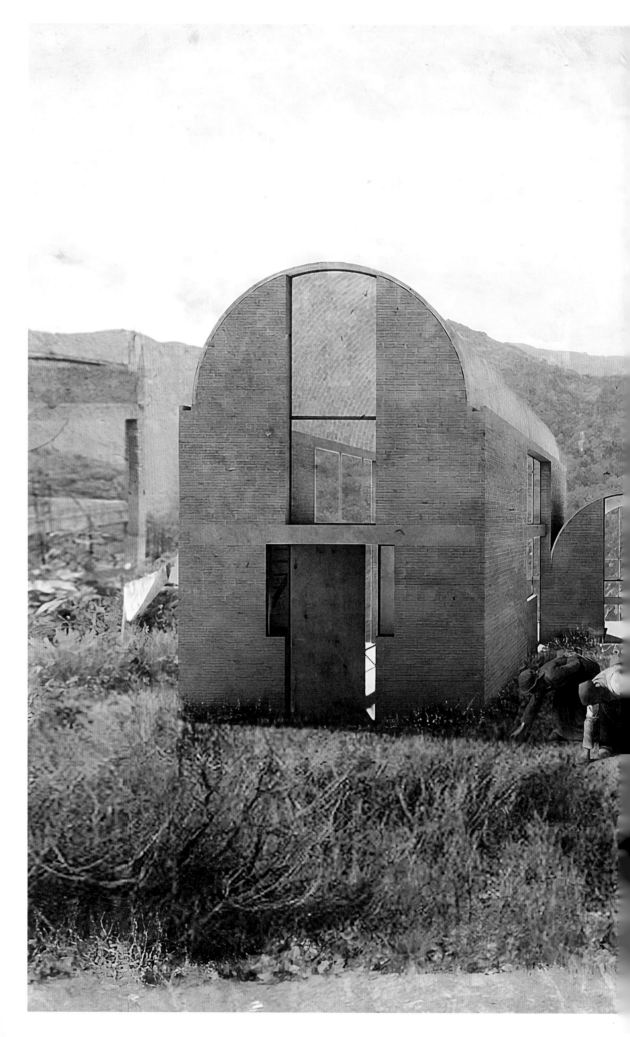

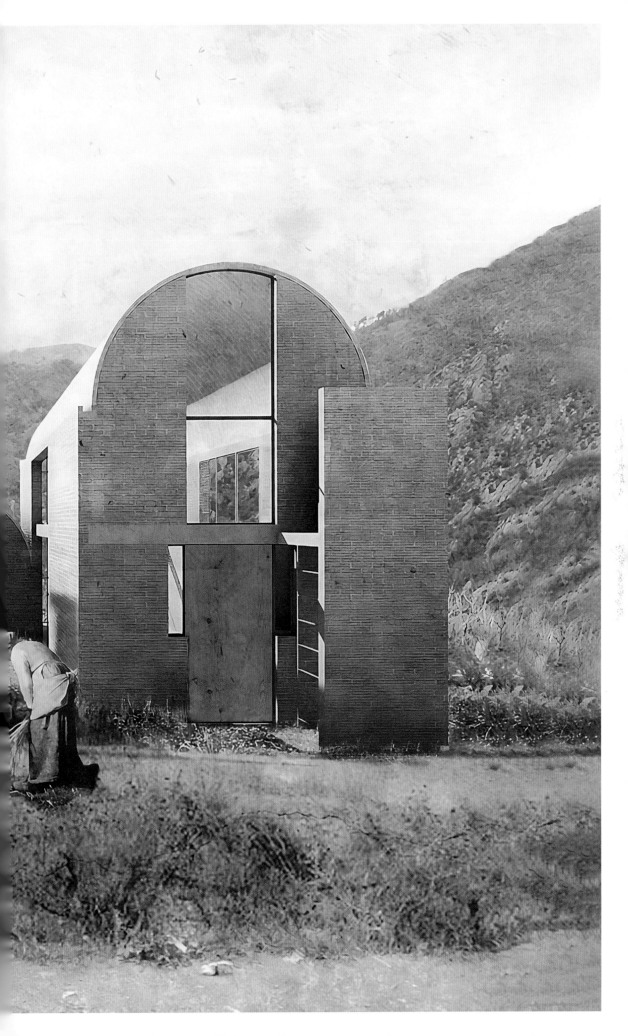

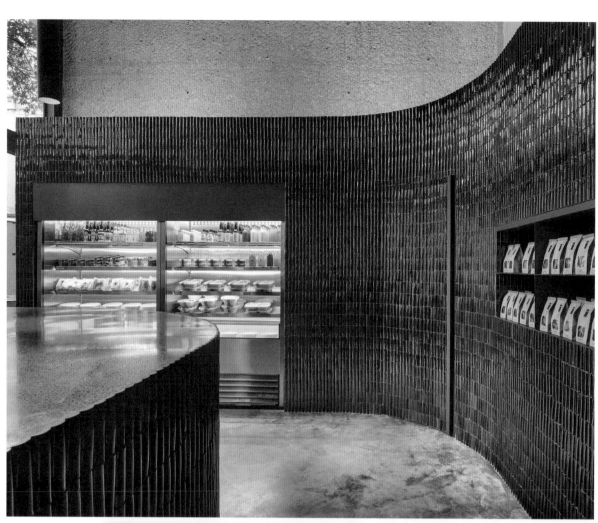

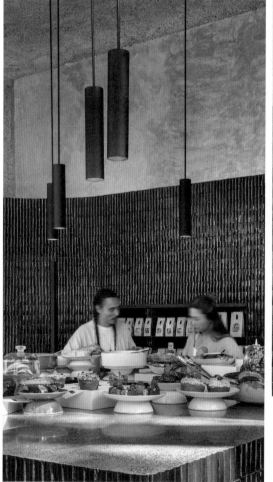

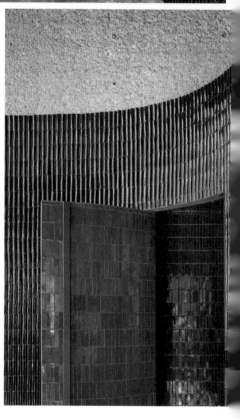

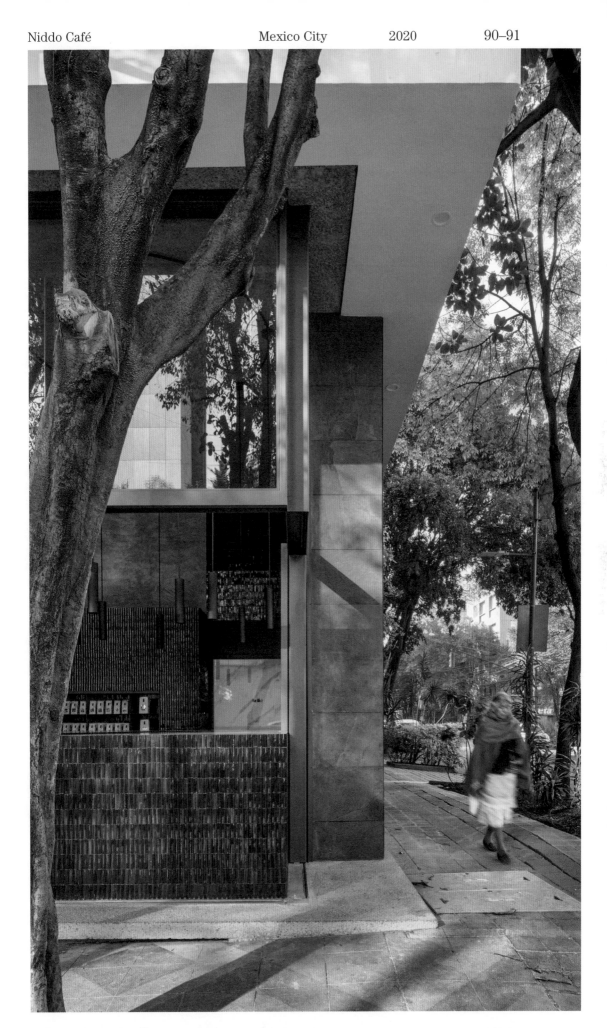

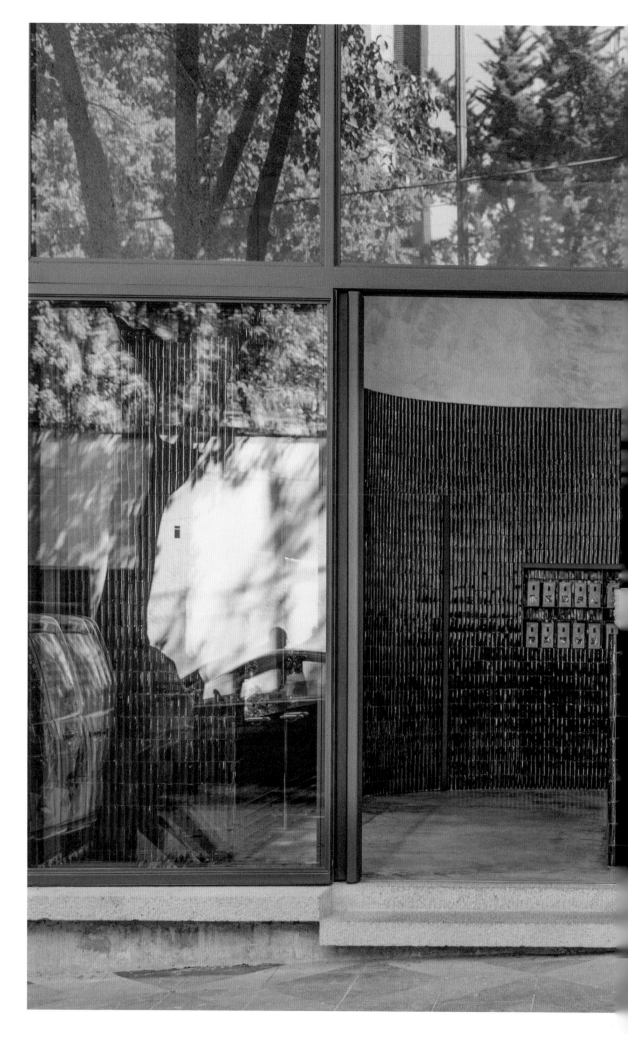

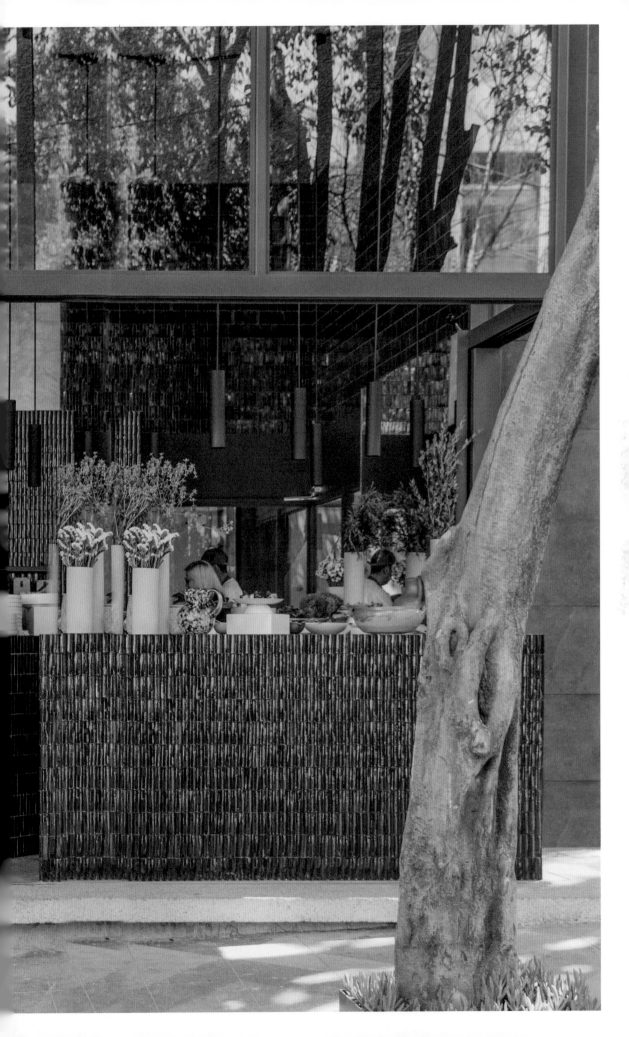

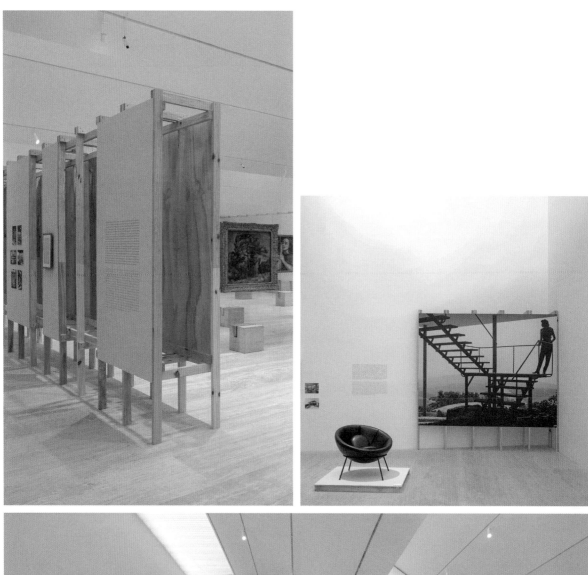

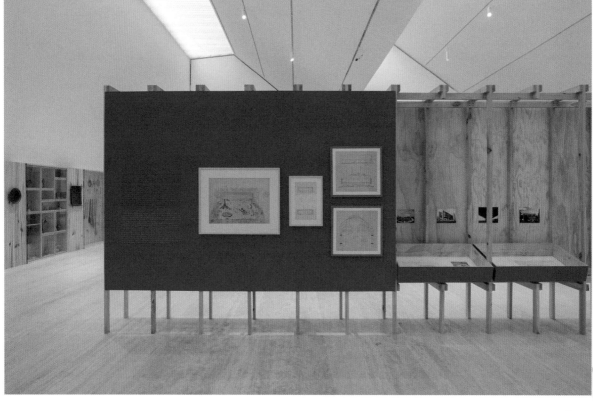

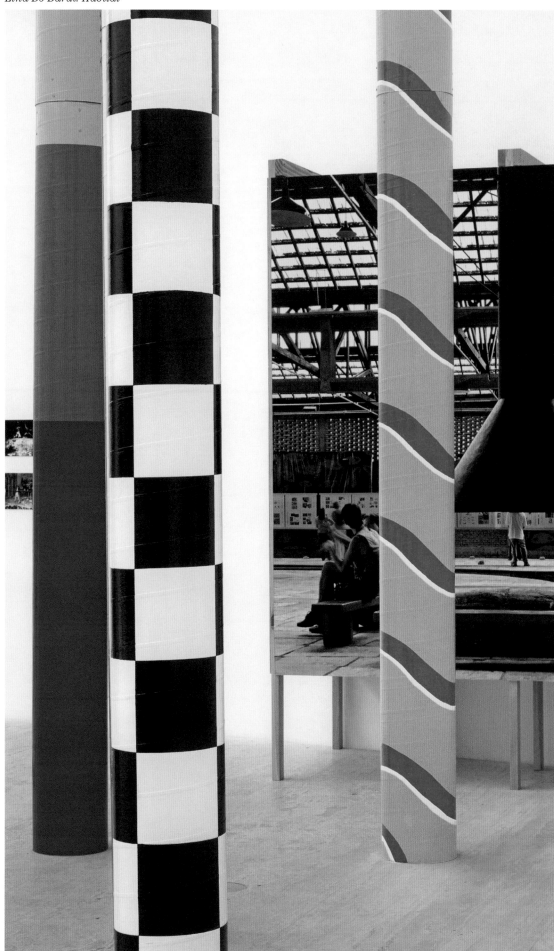

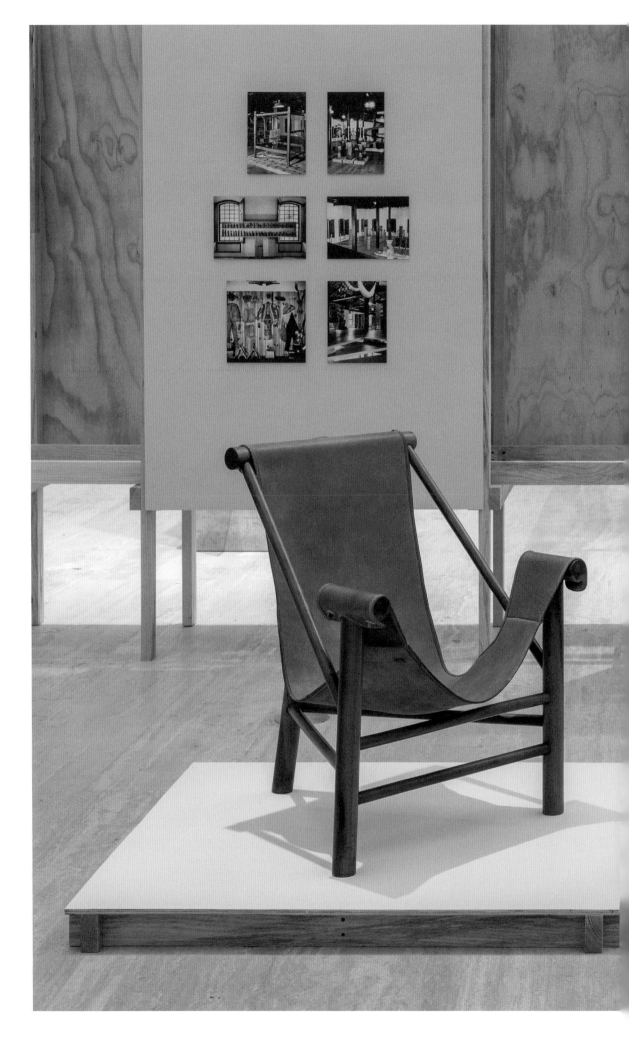

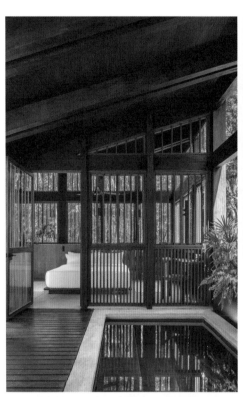

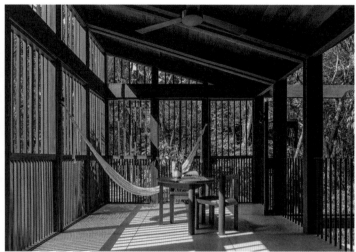

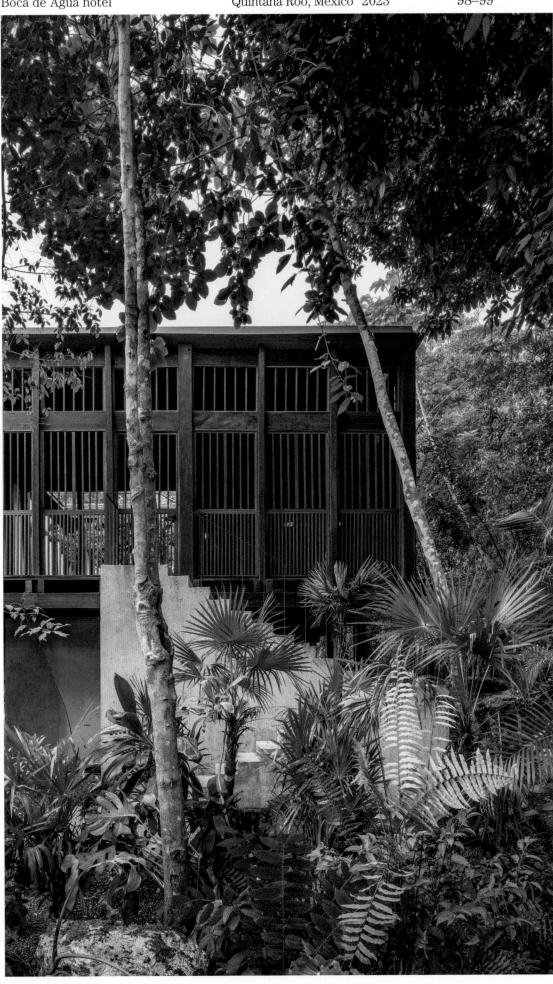

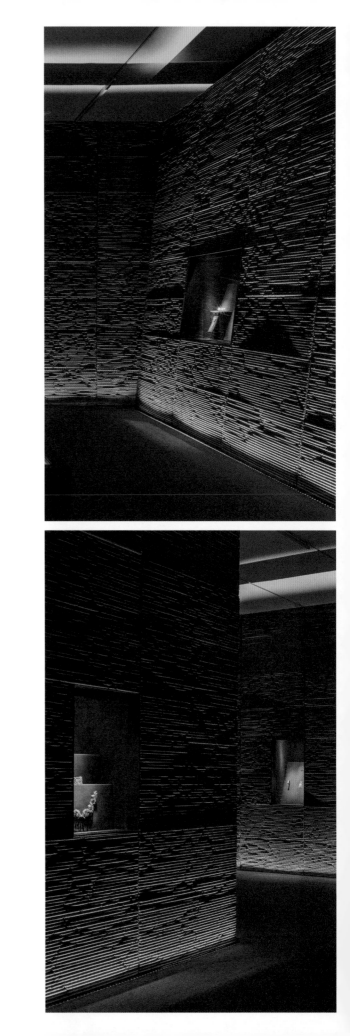

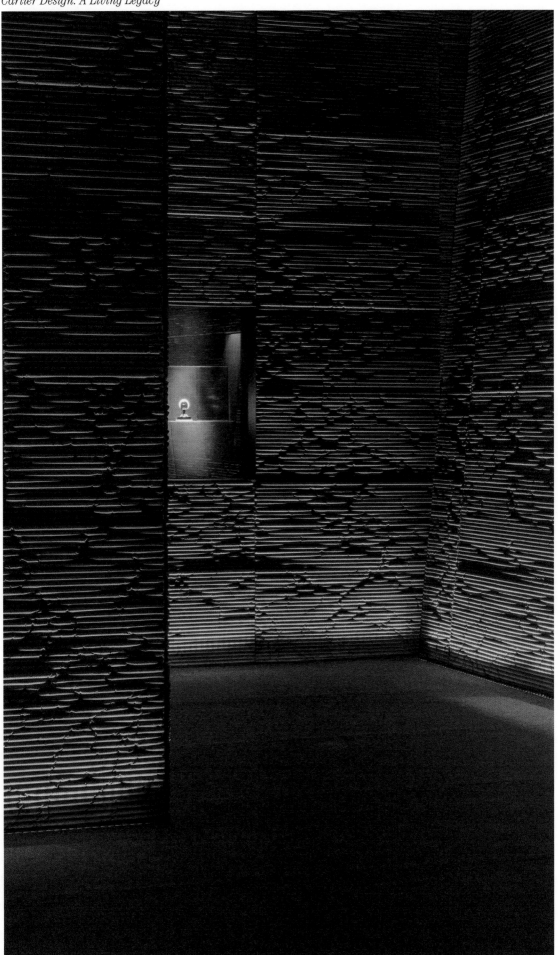

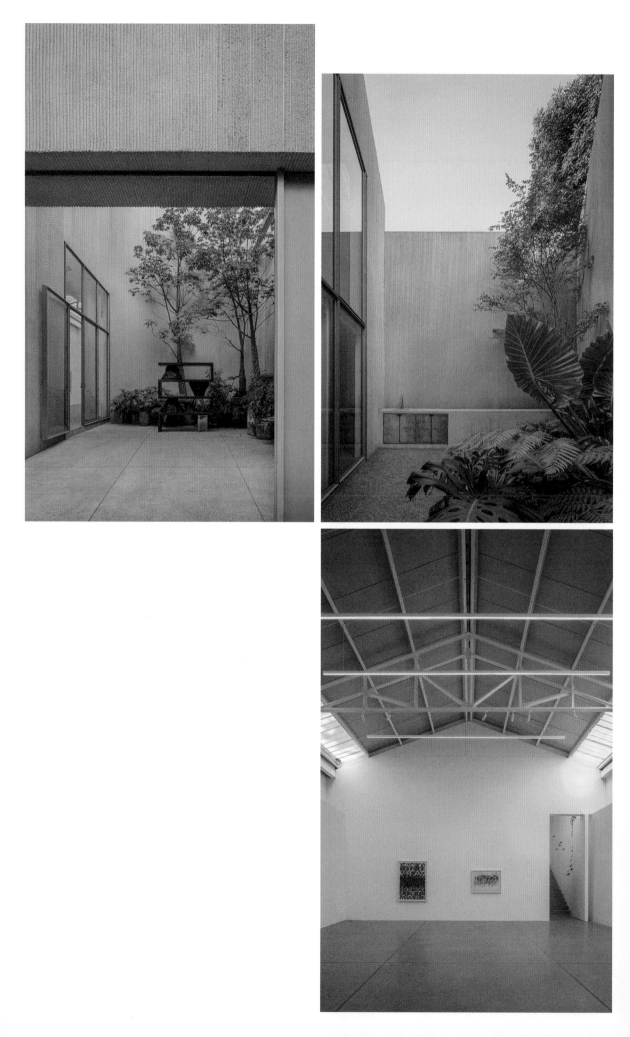

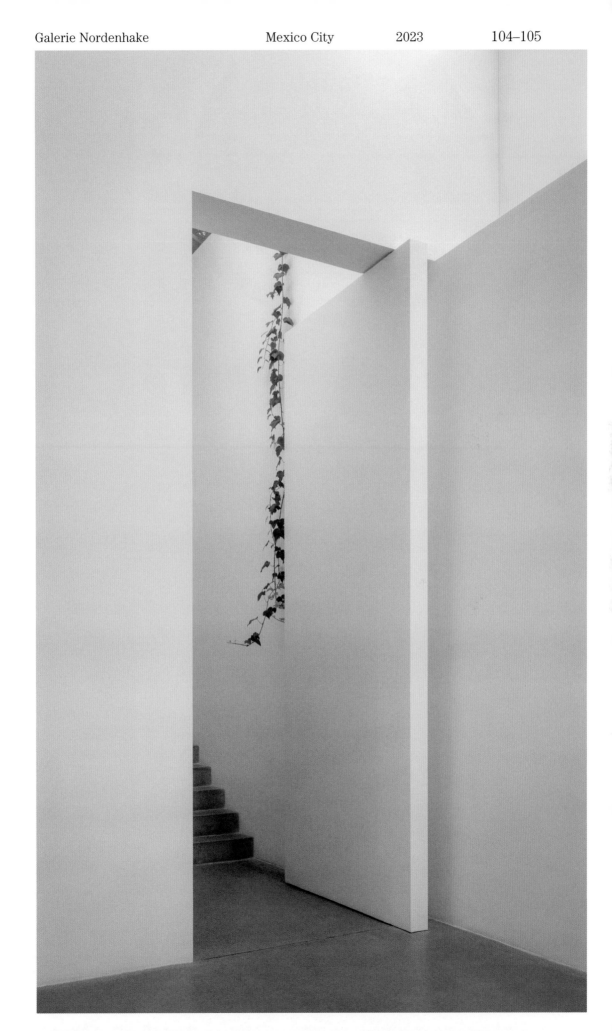

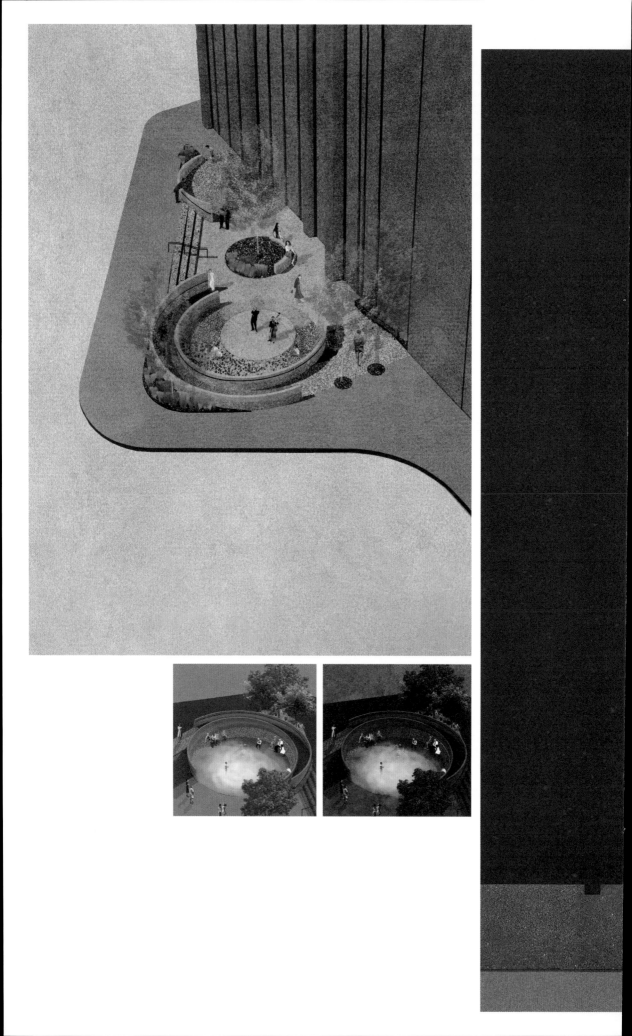

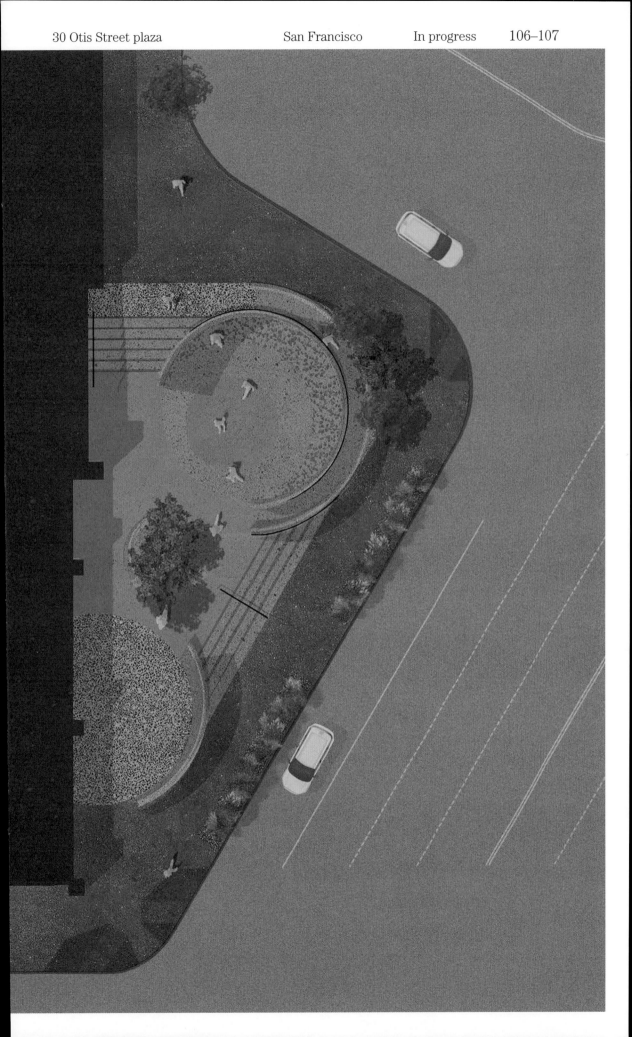

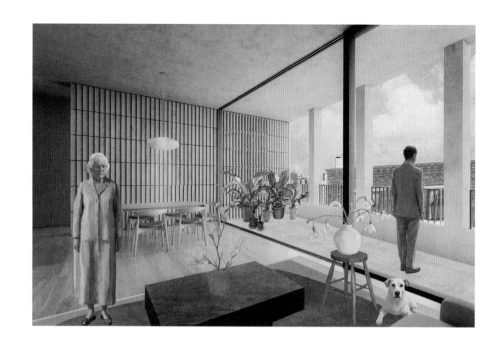

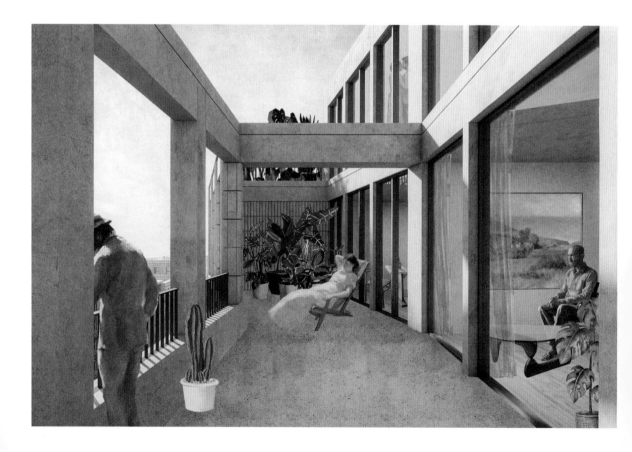

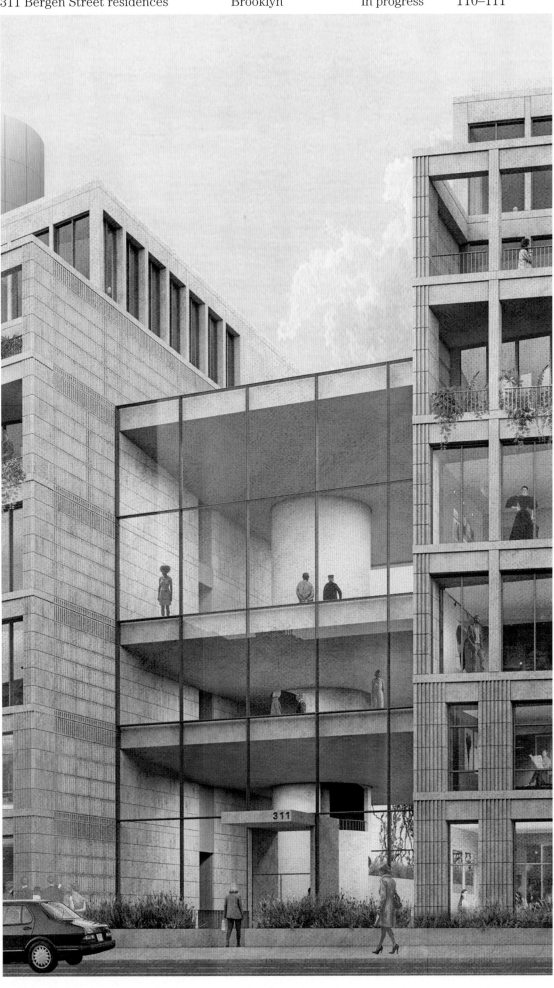

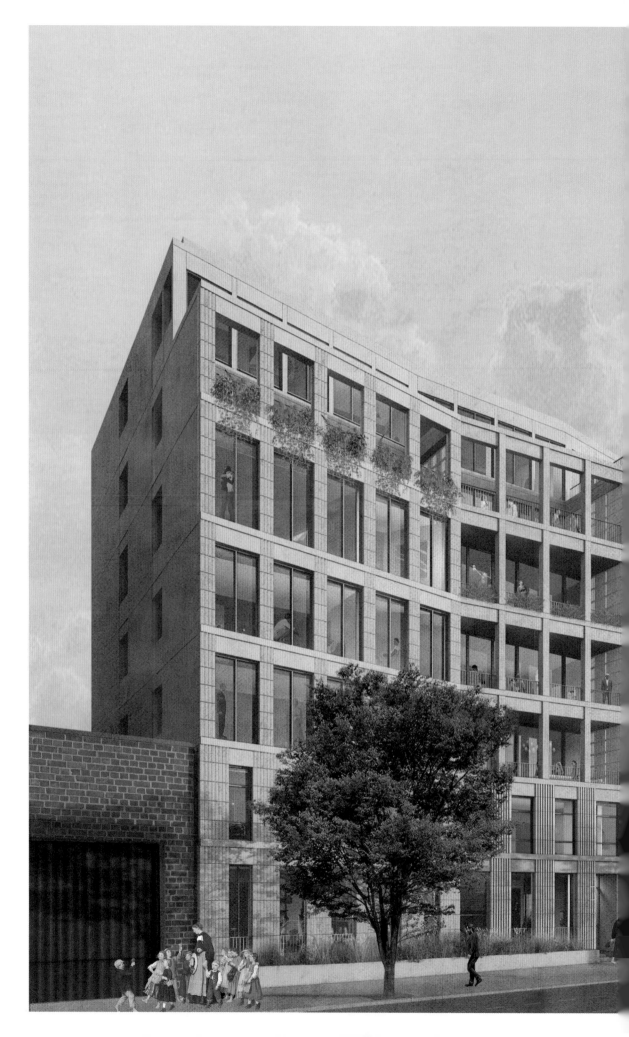

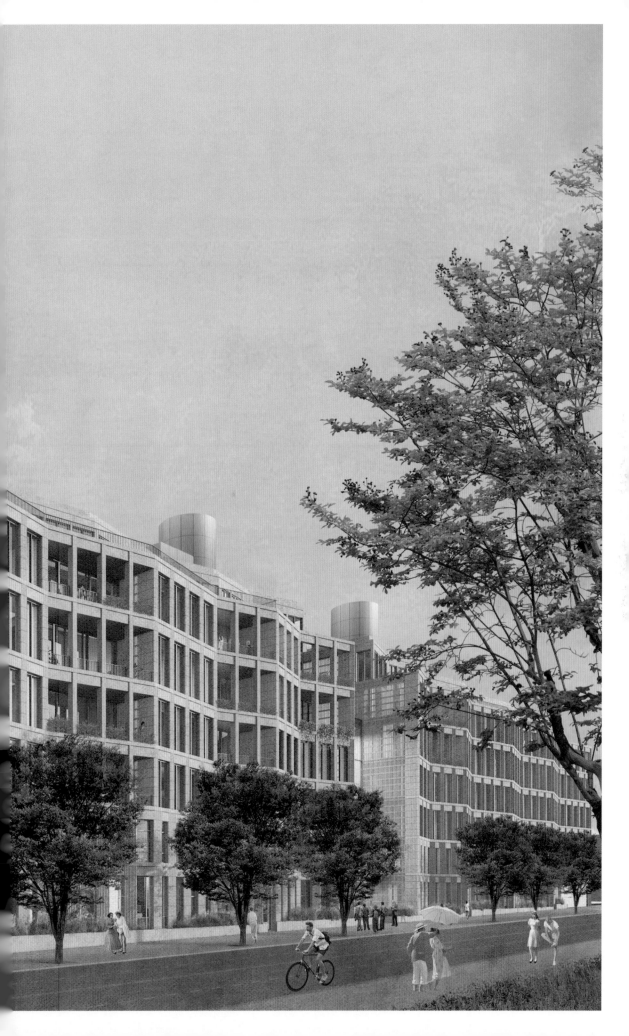

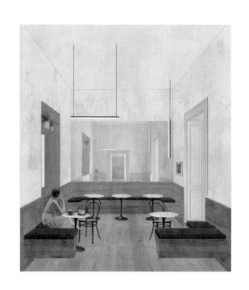

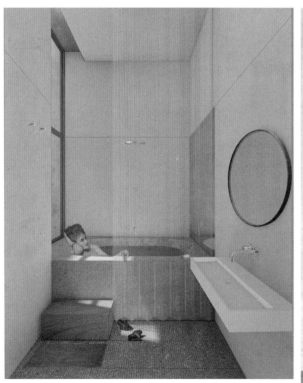

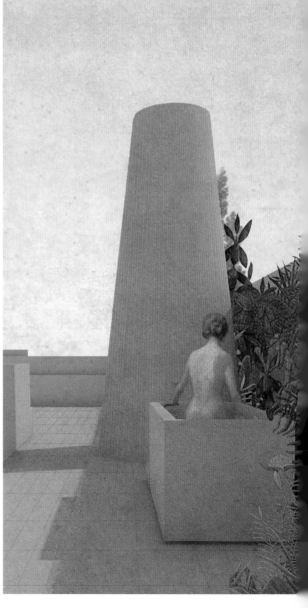

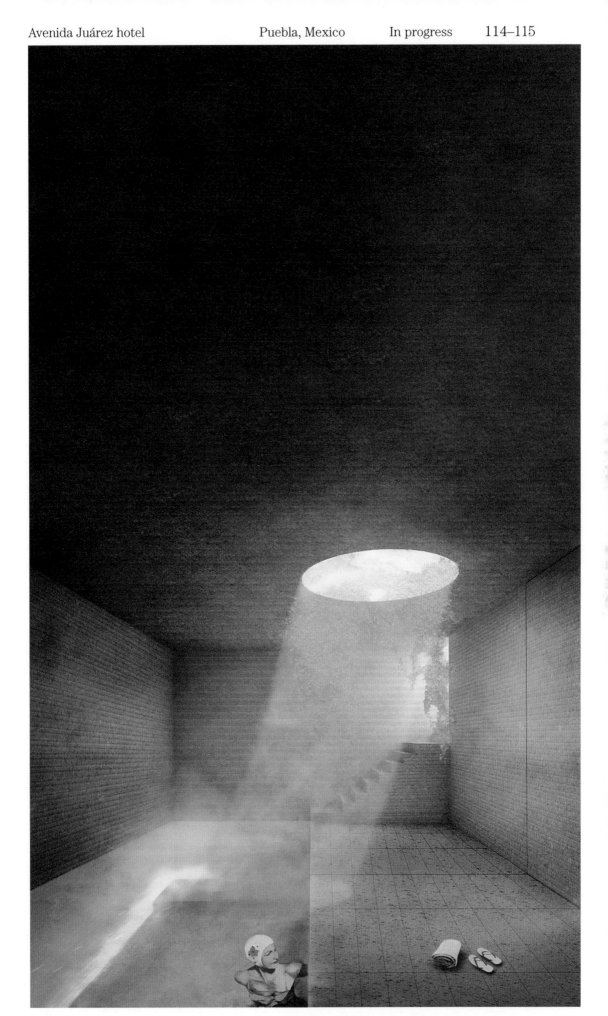

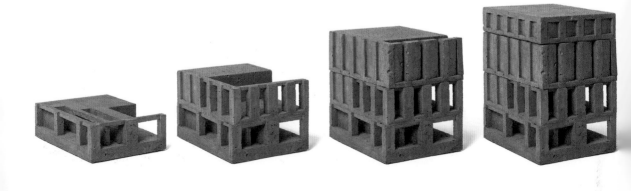

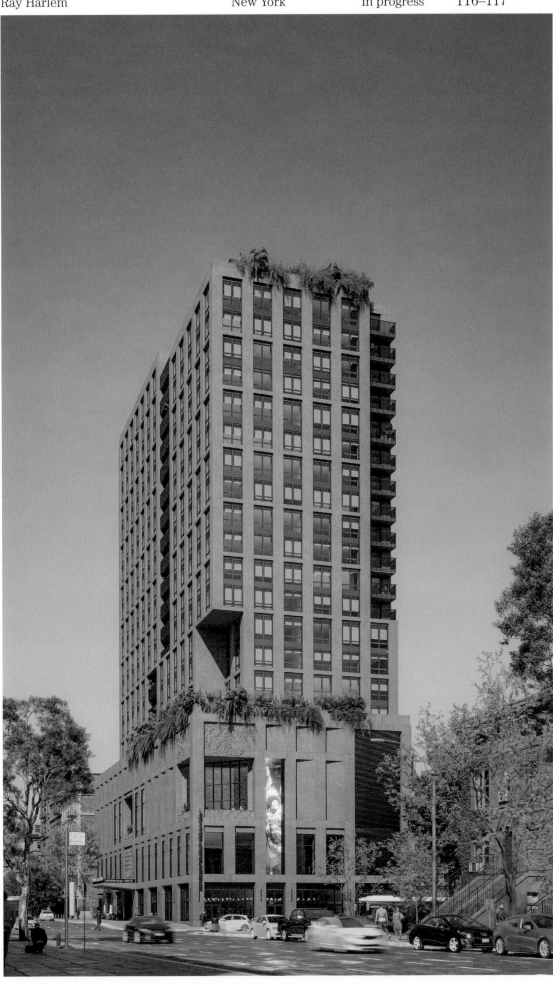

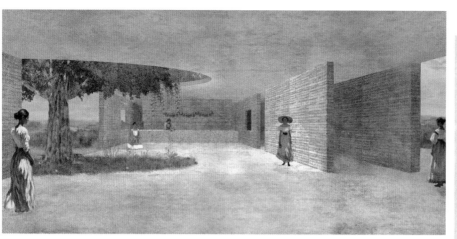

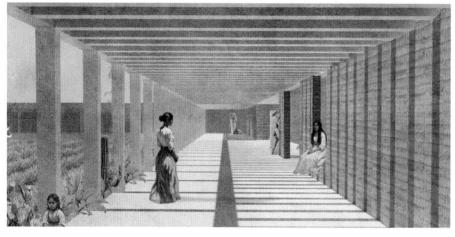

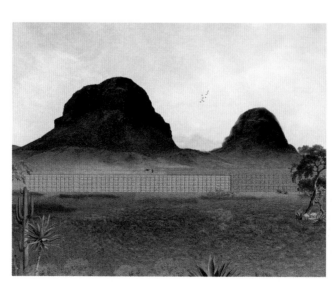

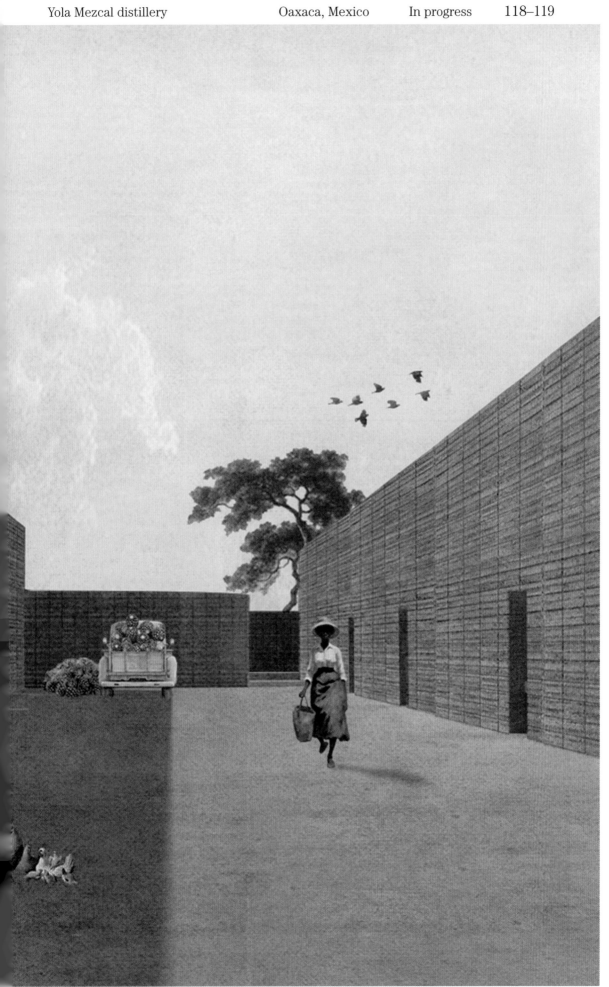

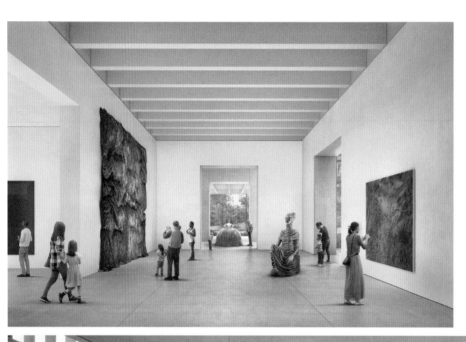

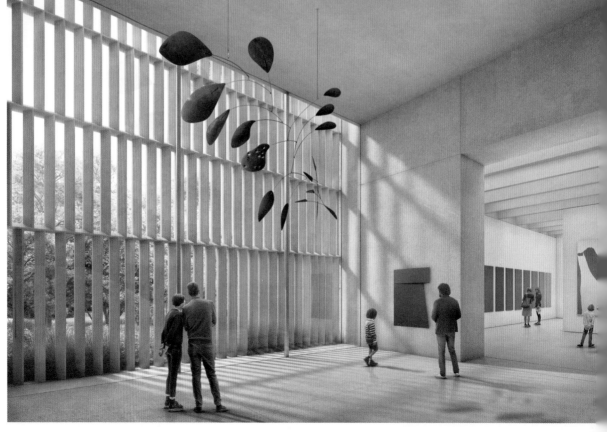

Oscar L. Tang and
H.M. Agnes Hsu-Tang Wing,
The Metropolitan Museum of Art

New York

In progress

120–121

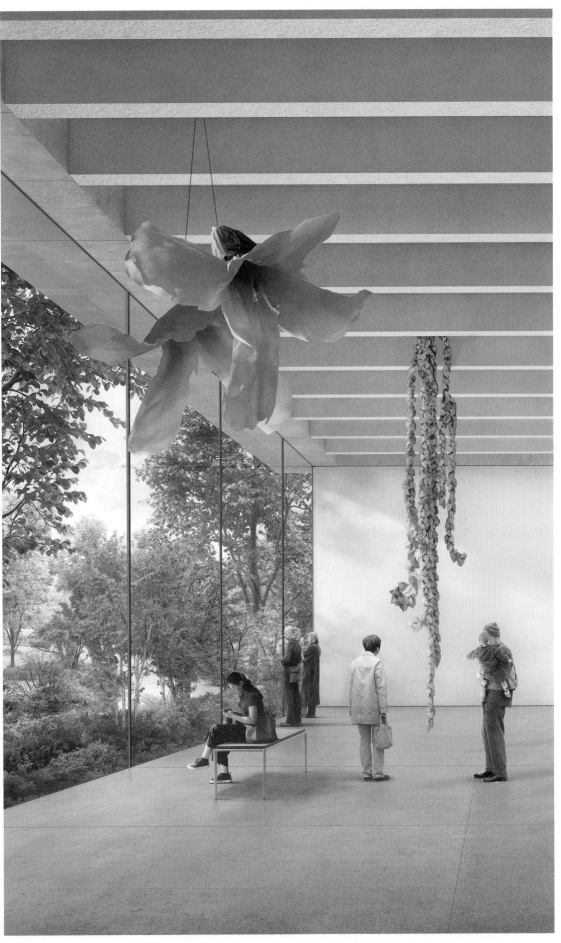

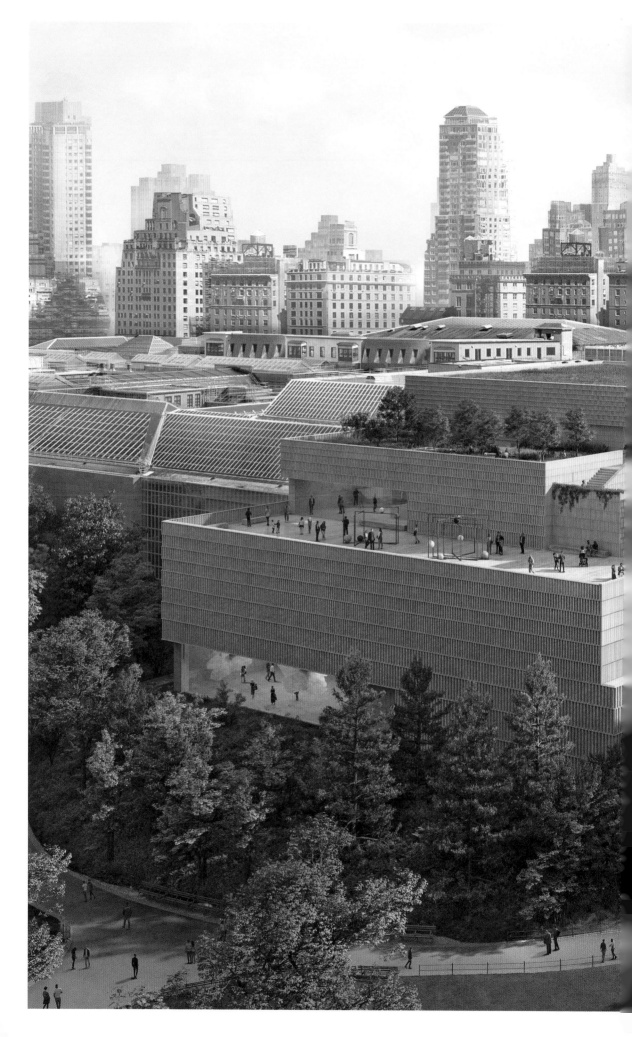

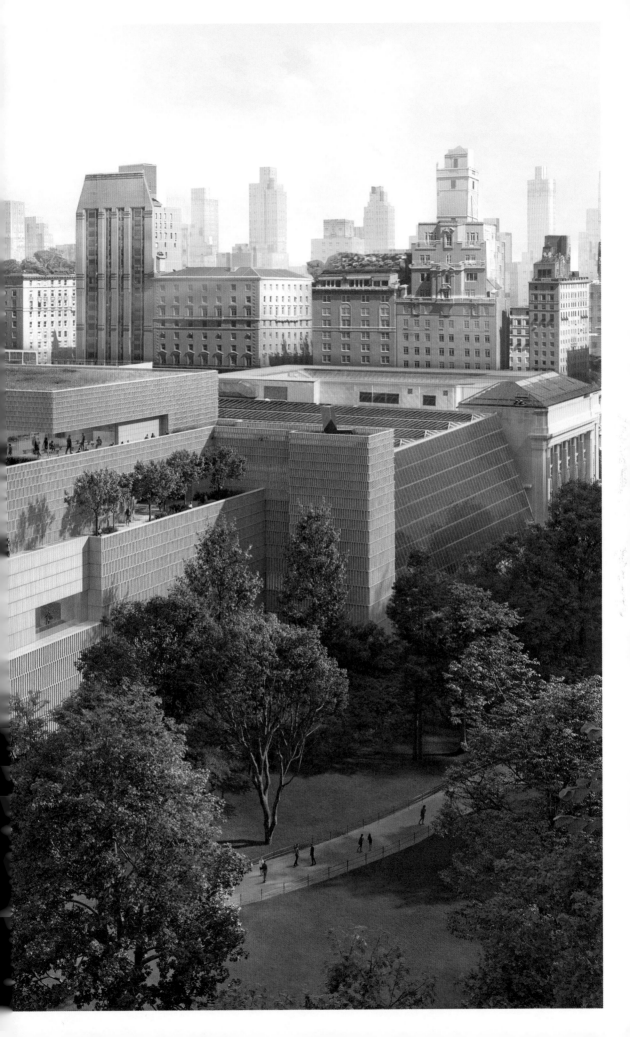

1. *The Fabricated Landscape*, ed. Raymund Ryan,
part 1, *Domestic*, exh. cat. (Pittsburgh: Carnegie Museum
of Art, 2021), p. 8.

2. Escobedo exhibits and discusses this same
project with the title *El Otro* in Spanish.

3. Frida Escobedo, "'Architecture is forever
unfinished,'" interview by Ronna Gardner, *Journal of
Visual Culture* 20, no. 1 (April 2021), p. 49.

4. Escobedo, interview by Gardner, p. 50.

5. Annie Ochmanek, "Frida Escobedo: Split
Subject," *Domus*, September 28, 2012, https://www
.domusweb.it/en/architecture/2012/09/28/frida-escobedo
-split-subject.html.

6. Frida Escobedo, "Florencia 72," in *Split
Subject* (self-published, 2019). I thank Frida Escobedo
and her team for allowing me access to this internal
publication.

7. Frida Escobedo, "Split Subject," Open House
Lecture, Harvard University Graduate School of Design,
October 31, 2019, Cambridge, Mass., video, 9:16, https://
www.gsd.harvard.edu/event/frida-escobedo-split-subject.

8. Michael Slenske, "Frida Escobedo,"
Architectural Digest 75, no. 9 (October 2018), p. 94.

9. Frida Escobedo, "Subtleness Does Not
Have to Be Ordinary," interview by András Szántó, in
Imagining the Future Museum: 21 Dialogues with Architects
by András Szántó (Berlin: Hatje Cantz, 2022), p. 89.

10. Escobedo, interview by Szántó, p. 90.

11. Escobedo, interview by Szántó, p. 91.

12. See Frida Escobedo, "Entangling Fire, Bone
+ Fragments," interview by Michaela Prunotto, *Inflection
Journal* 8 (December 2021), p. 19.

13. For further discussion of Niddo Café, see
Michaela Prunotto, "Lina Bo Bardi in Dialogue with Frida
Escobedo: A Spontaneous Entanglement," *Fabrications*
32, no. 1, pp. 130–31.

14. Frida Escobedo, in conversation with the
author, November 3, 2023.

15. Escobedo, interview by Gardner, p. 53.

16. Frida Escobedo, *The Book of Hours* (Dornbirn:
Zumtobel Group AG, 2023).

17. Frida Escobedo, "The Designer of the 2018
Serpentine Pavilion, Frida Escobedo," interview by Eva
Munz, *PIN-UP* 24 (Spring/Summer 2018), https://archive
.pinupmagazine.org/articles/mexican-architect-frida
-escobedo-serpentine-pavilion-designer-limited-edition
-magazine-cover.

18. Robert Smithson, "The Monuments of
Passaic," *Artforum* 6, no. 4 (December 1967), p. 50.
Italics in the original.

19. Smithson, "Monuments," p. 50. Italics in
the original.

20. Frida Escobedo, "In Conversation with
Frida Escobedo," interview by Hans Ulrich Obrist,
in *Frida Escobedo: Serpentine Pavilion 2018* (London:
Serpentine Galleries/Koenig Books, 2018), p. 132.

21. Frida Escobedo, *Build Up* (self-published,
2011), p. 5. I thank Frida Escobedo and her team for
allowing me access to this internal publication.

22. Escobedo, interview by Obrist, p. 132.

23. Amy Frearson, "Frida Escobedo creates
an Aztec-inspired installation in the V&A courtyard,"
Dezeen, May 28, 2015, https://www.dezeen.com
/2015/05/28/frida-escobedo-aztec-installation-landscape
-victoria-albert-courtyard-london.

24. Frida Escobedo, *Portfolio* (self-published,
2023), p. 209. I thank Frida Escobedo and her team for
allowing me access to this internal publication.

25. Octavio Paz, *The Other Mexico: Critique of the
Pyramid*, trans. Lysander Kemp (New York: Grove Press,
1972), p. viii; cited with slight differences in Escobedo,
Split Subject.

26. Escobedo, *Portfolio*, p. 105.

27. See Frida Escobedo, "Jesús Vassallo In
Conversation With Frida Escobedo," interview by Jesús
Vassallo, *PLAT* 8 (Fall 2019), pp. 54–55.

NOTES

28. Frida Escobedo, "Frida Escobedo: 'I don't think there should only be one concept of home,'" interview by Alejandra González Romo, *Aperture* 238 (Spring 2020), p. 55.

29. Escobedo, in conversation with the author, November 3, 2023.

30. Escobedo, *Portfolio*, p. 101.

31. Frida Escobedo, *Domestic Orbits* (Mexico City: Gato Negro Ediciones, 2019).

32. Alex Anderson, "Domestic Orbits: Frida Escobedo on architecture's tendency to conceal spaces of domestic labor," Harvard Graduate School of Design, October 11, 2019, https://www.gsd.harvard.edu/2019/10/domestic-orbits-frida-escobedo-on-architectures-tendency-to-conceal-spaces-of-domestic-labor.

33. Frida Escobedo, "Prospective/Retrospective," *Domus* 963 (November 2012), p. 3.

34. Escobedo, interview by Obrist, p. 132.

35. Frida Escobedo, *Double Bind* (self-published, 2015). I thank Frida Escobedo and her team for allowing me access to this internal publication.

36. Frida Escobedo, final presentation for the Tang Wing architectural competition, February 7, 2022.

37. As cited in Escobedo, "Prospective/Retrospective," p. 3; see Paz, *The Other Mexico*, p. 81.

ARCHITECTURE AS LANGUAGE (20–27)
Paola Santos Coy

1. Frida Escobedo, "Designing Tomorrow's Met," MetSpeaks lecture, The Metropolitan Museum of Art, October 20, 2022, New York, video, 11:00, https://www.youtube.com/watch?v=FLrzCZGi9zY.

2. Escobedo, "Designing Tomorrow's Met," 10:10.

3. Escobedo, "Designing Tomorrow's Met," 9:35.

4. Adrienne Rich, "Adrienne Rich on the Powerful, Powerless Mother," 1989 interview by Terry Gross, NPR, March 30, 2012, https://www.npr.org/2012/03/30/149678681/adrienne-rich-on-the-powerful-powerless-mother.

5. Zeuler R. M. de A. Lima, "Lina Bo Bardi and the Architecture of Everyday Culture," *Places Journal* (November 2013), https://doi.org/10.22269/131112.

6. The pavilion at El Eco, heir in many respects to the pavilion format launched around 2000 by institutions like the Serpentine galleries in London or PS1/MoMA in New York, started in 2010 as an annual architecture competition to create a place for spatial reflection at the Mexico City museum. It was established by Tobias Ostrander, the director of the Museo Experimental el Eco from 2009 to 2011, and Jorge Munguía, his curatorial collaborator for the accompanying public program. It continues today as a biennial competition.

7. See Mathias Goeritz's speech, "Manifiesto de Arquitectura Emocional, 1953," Museo Experimental el Eco, September 7, 1953, https://eleco.unam.mx/manifiesto-de-la-arquitectura-emocional-1953. First published as "El Eco: Arquitectura emocional," in *Cuadernos de Arquitectura* 1 (March 1954).

8. See Goeritz's preparatory notes for the opening of El Eco in 1953, facsimile reproduced in David Miranda, *Manifiesto emocional: El sentido de un museo experimental* (2021), pp. 16–17, https://eleco.unam.mx/manifiesto-emocional.

9. Jasia Reichardt, "Los ámbitos de la poesía concreta," in *Poesía concreta internacional*, exh. cat., ed. Mathias Goeritz (Mexico City: Galería Universitaria Aristos, Universidad Nacional Autónoma de México, 1966).

10. Jennifer Josten, "Mathias Goeritz y poesía concreta internacional," Museo Experimental el Eco, October 29, 2019, https://eleco.unam.mx/goeritz-y-poesia-concreta-internacional.

11. Frida Escobedo, "Pabellón Eco 2010," Museo Experimental el Eco, March 20, 2010, https://eleco.unam.mx/expo/pabellon-eco-2010.

12. Goeritz, "Manifiesto."

13. Daniel Garza Usabiaga, *Mathias Goeritz y la arquitectura emocional: Una revision crítica (1952–1968)* (Mexico City: Vanilla Planifolia, 2013), pp. 34–35.

14. Mathias Goeritz, "La serpiente de El Eco," in *Pensamientos y dudas autocríticas: El Eco de Mathias Goeritz*, ed. Leonor Cuahonte (Mexico City: Turner, 2015), p. 96. First published in 1970.

15. Frida Escobedo, "Serpentine Architecture: Frida Escobedo in conversation," interview by Mohsen Mostafavi, Marina Otero Verzier, and Hans Ulrich Obrist, June 12, 2018, video, 21:57, https://www.youtube.com/watch?v=yoytqQy9rJ0.

16. Marina Otero Verzier, "Protection and Position," in *Frida Escobedo: Serpentine Pavilion 2018* (London: Serpentine Galleries/Koenig Books, 2018), p. 38.

17. In 1965, in the Mexican city of Cuernavaca, David Alfaro Siqueiros and his wife, Angélica Arenal, founded the artist's studio with the aim of creating a workspace that would allow the painter to execute a large-scale work commissioned by the businessman Manuel Suárez y Suárez for the Hotel Casino de la Selva. This space became a meeting point for artists and tradespeople involved in the creation of this work. About twenty years after Siqueiros's 1974 death, La Tallera opened to the public as a cultural center and museum; in 2010, then-director Taiyana Pimentel commissioned Escobedo to renovate the space. "Historia La Tallera," Sala de Arte Público Siqueiros–La Tallera, http://saps-latallera.org/tallera/historia.

18. Frida Escobedo, "'Architecture is forever unfinished,'" interview by Ronna Gardner, *Journal of Visual Culture* 20, no. 1 (April 2021), p. 57.

FRIDA ESCOBEDO AT THE MET (28–31)
Max Hollein

1. Dodie Kazanjian, "Frida Escobedo Has New Vision for the Met," *Vogue*, March 22, 2023, https://www.vogue.com/article/frida-escobedo.

2. "Architecture on Time: Frida Escobedo and José Esparza Chong Cuy," August 1, 2023, in *CHANEL Connects*, directed by Emily Okuda-Overhoff, podcast, MP3 audio, 7:28.

3. "Architecture on Time," 5:05.

4. Frida Escobedo, "Frida Escobedo: 'Mexican architecture is an architecture of layering,'" interview by ArchDaily editorial team, June 11, 2018, video, 1:20, https://www.youtube.com/watch?v=mqsN7jNNMAg.

5. See Morrison H. Heckscher, "An Edifice for Art," in *Making the Met, 1870–2020*, ed. Andrea Bayer with Laura D. Corey (New York: The Metropolitan Museum of Art, 2020), pp. 18–31.

INDEX

DAVID BRESLIN is Leonard A. Lauder Curator
in Charge of the Department of Modern and
Contemporary Art at The Metropolitan Museum
of Art, New York.

FRIDA ESCOBEDO established her eponymous studio
in Mexico City in 2006. She is the architect of
the Oscar L. Tang and H.M. Agnes Hsu-Tang Wing
of The Metropolitan Museum of Art, New York.

JHAELEN HERNANDEZ-ELI is the former Vice President
of Capital Projects at The Metropolitan Museum of
Art, New York.

MAX HOLLEIN is Marina Kellen French Director
and CEO of The Metropolitan Museum of Art,
New York.

NADINE M. ORENSTEIN is Drue Heinz Curator in Charge
of the Department of Drawings and Prints
at The Metropolitan Museum of Art, New York.

JEFF L. ROSENHEIM is Joyce Frank Menschel Curator
in Charge of the Department of Photographs
at The Metropolitan Museum of Art, New York.

PAOLA SANTOS COY is an independent curator.
She was Director of the Museo Experimental
el Eco, Mexico City, from 2013 to 2023.

ABRAHAM THOMAS is Daniel Brodsky Curator of Modern
Architecture, Design, and Decorative Arts
in the Department of Modern and Contemporary
Art at The Metropolitan Museum of Art, New York.

CONTRIBUTORS

One of the pleasures of leading a museum is to watch colleagues pour their energies and creativity into a project. The book that you hold in your hands is the product of a particularly satisfying collaboration. The team behind *Suspended Moment: The Architecture of Frida Escobedo* was united in its enthusiasm for the work of an inspiring architect and the prospect of new galleries for modern and contemporary art at The Met.

I would like to thank Frida Escobedo for her remarkable vision and good nature. It has been wonderful to collaborate with her and with the team at Frida Escobedo Studio: Velia Aguirre, Alejandro Alegría, Lucero Arenas, Ana Batlle, Juan Pablo Bravo, Víctor Cruz, Ariana Cruz Palacios, Elsa Fisbein, Sócrates García, José Luis González, Fernanda Hinojosa Adalid, Marco Hwang, Rhiannon Inners, Sana Jahani, Amanda Kemeny, Axel de la Orta, Jonathan Larsen Parker, César Lima, Alonso López, Victoria Oriana Marquez, Luis Mendoza, Rogelio Morales, Alberto Montesinos, Josué Palma, Elizabeth Reyes, Adriana Rojas, Juan Pablo Ruiz, Miguel Sanchez Enkerlin, Andrea Schelly, Ali Sherif, Anne Francesca Vandeven, and Margaux Wheelock-Shew. Particular thanks are owed to Iva Keselicová for her assistance throughout this project.

I also wish to acknowledge the contributions to these pages from colleagues at The Met: David Breslin, Leonard A. Lauder Curator in Charge of the Department of Modern and Contemporary Art; Jhaelen Hernandez-Eli, former Vice President of Capital Projects; Nadine M. Orenstein, Drue Heinz Curator in Charge of the Department of Drawings and Prints; Jeff L. Rosenheim, Joyce Frank Menschel Curator in Charge of the Department of Photographs; and Abraham Thomas, Daniel Brodsky Curator of Modern Architecture, Design, and Decorative Arts. Thanks also to Paola Santos Coy for contributing an essay on Escobedo's architectural language.

I am grateful to other colleagues who were integral to the completion of this project: Inka Drögemüller, Deputy Director for Audience Engagement; Brinda Kumar, Associate Curator, Department of Modern and Contemporary Art; and Karina Gilbert, Senior Project Manager, Capital Projects.

As always, I deeply appreciate the work of the Publications and Editorial Department, led by Mark Polizzotti, Peter Antony, and Michael Sittenfeld. My thanks go to the superb team responsible for this remarkable publication: Cecilia Weddell, Chris Zichello, and Shannon Cannizzaro. The engaging design of this book is the work of Maricris Herrera of Estudio Herrera in Mexico City.

We thank the Roswell L. Gilpatric Fund for Publications and the Director's Fund for supporting the creation of this beautiful book and enabling us to share it with the Museum's readers.

Max Hollein
Marina Kellen French Director and CEO
The Metropolitan Museum of Art

ACKNOWLEDGMENTS

PHOTOGRAPHY CREDITS

This publication is made possible by the ROSWELL L. GILPATRIC FUND FOR PUBLICATIONS.

Additional support is provided by the DIRECTOR'S FUND.

Published by
THE METROPOLITAN MUSEUM OF ART, NEW YORK

Mark Polizzotti, PUBLISHER AND EDITOR IN CHIEF

Peter Antony, ASSOCIATE PUBLISHER FOR PRODUCTION

Michael Sittenfeld, ASSOCIATE PUBLISHER FOR EDITORIAL

EDITED BY Cecilia Weddell

PRODUCTION AND COLOR SEPARATIONS BY Christopher Zichello

DESIGNED BY Maricris Herrera, Estudio Herrera

IMAGE ACQUISITIONS AND PERMISSIONS BY Shannon Cannizzaro

TRANSLATIONS FROM SPANISH BY Philip Sutton

PHOTOGRAPHY CREDITS appear on page 130.

TYPESET IN ITC Century Std

PRINTED ON 140 gsm Arena Rough White

COLOR PROOFING BY ALTAIMAGE, New York and London

PRINTED BY Brizzolis, Madrid

PRINTING AND BINDING COORDINATED BY Ediciones El Viso, Madrid

COVER ILLUSTRATIONS: front left, Frida Escobedo Studio, Serpentine Pavilion (detail), London, 2018 (fig. 4); front right, Frida Escobedo Studio, La Tallera (detail), Cuernavaca, Mexico, 2012; back, Frida Escobedo Studio, Serpentine Pavilion (conceptual study), 2018 (fig. 14)

The Metropolitan Museum of Art
1000 Fifth Avenue
New York, New York 10028
metmuseum.org

Distributed by Yale University Press, New Haven and London
yalebooks.com/art
yalebooks.co.uk

Authorized Representative in the EU: Easy Access System Europe, Mustamäe tee 50, 10621 Tallinn, Estonia, gpsr.requests@easproject.com

Cataloguing-in-Publication Data is available from the Library of Congress.
ISBN 978-1-58839-786-7